Paul Rand

Design
Form
and
Chaos

 Yale University Press
New Haven and London
1993

The following essays by Paul Rand
are reprinted with the permission of the
original publishers. Most have been
updated and edited.

Good Design Is Goodwill
AIGA Journal, 1987

Intuition and Ideas
American Center for Design Journal, 1987

Logos…Flags…Street Signs
AIGA Journal, 1990

Computers, Pencils, and Brushes
IBM, 1992

Aspects of Book Design
Copyright © 1989 by The New York Times Company

A Mentor (Jan Tschichold: The New Typography)
PRINT, January/February 1969

From Cassandre to Chaos
AIGA Journal, 1992

Illustration on p. 205 from
Desmond Morris, *The Biology of Art*
(New York: Knopf, 1962), 48

Illustration on p. 208 from
March Dachy, *The Dada Movement*
(New York: Rizzoli International, 1990), 99

Illustration on pp. 219-20 from
Shigeo Fukuda (Tokyo: Kodansha, 1979), 4

Designed by Paul Rand.

Typesetting by PDR Royal, Inc.
New York, N.Y.
Printed in U.S.A. by Mossberg & Company Inc.
South Bend, Indiana.

L.C. 92 - 62277

ISBN 0 - 300 - 05553 - 6

10 9 8 7 6 5 4 3 2 1

For Swan

All that Adolf Loos and I did, he literally, I linguistically,
was to show that there is a difference between an urn and a chamberpot,
and that in this difference there is leeway for culture.
But the others, the "positive ones," are divided into those who use the urn
as a chamberpot and those who use the chamberpot as an urn.

Karl Kraus

Contents

Introduction

Everything we do has some aesthetic implication. It was John Dewey's contribution to the philosophy of art to point out that art is not something special but a significant part of daily experience, and that a real understanding of life is synonymous with aesthetic enjoyment.

John Dewey,
"The Living Creature,"
ART as Experience
(New York, 1934), 4

"In order to *understand* the aesthetic in its ultimate and approved forms, one must begin with it in the raw; in the events and scenes that hold the attentive eye and ear of man, arousing his interest and affording him enjoyment as he looks and listens: the sights that hold a crowd — the fire-engine rushing by; the machines excavating enormous holes in the earth; the human-fly climbing the steeple-side; the men perched high in air on girders, throwing and catching red-hot bolts. The sources of art in human experience will be learned by him who sees how the tense grace of the ball-player infects the onlooking crowd; who notes the delight of the housewife in tending her plants."

Most great art, isolated in museums or private collections, is perceived as something different — existing on a pedestal — not as part of one's day-to-day experience. On the other hand, most design (great or otherwise) of printed ephemera, logos, advertisements, brochures, posters, and television commercials is so much a part of everyday experience that eventually it finds itself not on a pedestal but on a rubbish heap. The purpose of this book is to demonstrate the relevance of design to ordinary experience and to indicate its relationship to the world of art, education, and business. It is also intended to make one aware of the place of design in other areas. Vaclav Havel, the former president of Czechoslovakia, commented in *Time* magazine (August 3, 1992) on the connection between what he called *taste* and governing: "I came to this castle and I was confronted with tasteless furniture and tasteless pictures. Only then did I realize how closely the bad taste of rulers was connected with their bad way of ruling." Of course, Mr. Havel was talking about aesthetics and design. Even though this may not always be the case, Mr. Havel's observation is a provocative one.

The use of Caslon 540 in this book may suggest that the author has suddenly done a turnabout. Its purpose, however, is to demonstrate the difference between the *what* and the *how*. Although Caslon is stylistically traditional, the way it is used is not. If a sans serif had been used, it would have been different in flavor, but not in substance — like the difference between chocolate and vanilla.

Most of the illustrations in this book are the work of the author. Words about art and design are best explained in the presence of the artist's work. The reader, then, can more readily understand what the writer is talking about, and whether opinions expressed are based on empirical or theoretical values.

Thanks to Judy Metro and to the editors at Yale University Press for heroic efforts; to Mossberg and Company and to James Hillman for his vigilance and expertise; and to PDR/Royal and Mario Rampone for typesetting and computer assistance; especially to Nick Juliano for diligence, infinite patience, and a watchful eye; and lastly, to my wife for even more patience.

Paul Rand
Weston, Connecticut

Form + Content

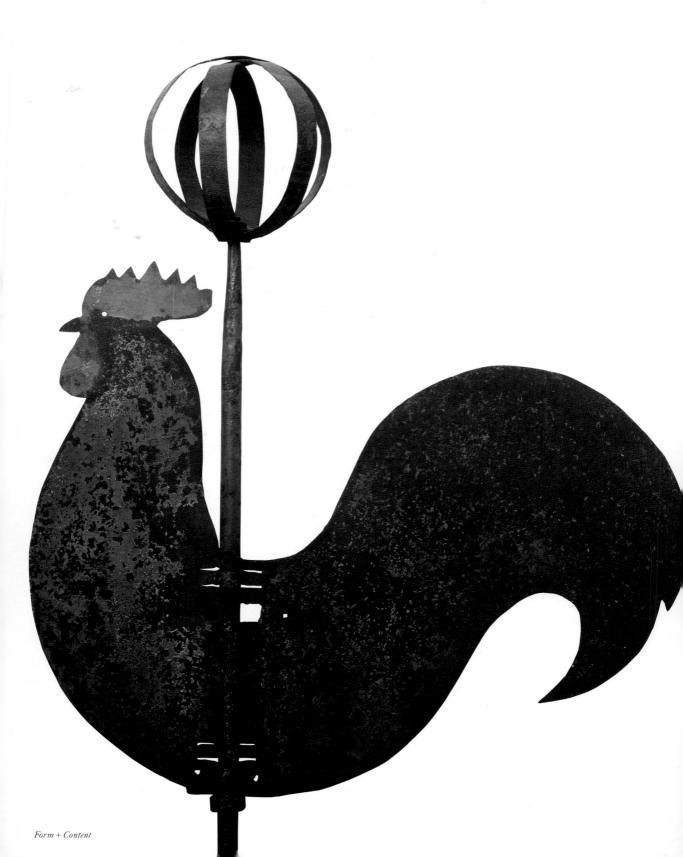

To understand the meaning of design is to sense the common thread that weaves its way through the arts of painting, architecture, and industrial and graphic design. It is also to understand the part form and content play in the intricate process of design, and to realize as well that design is also commentary, opinion, a point of view, and social responsibility.

To design is much more than simply to assemble, to order, or even to edit; it is to add value and meaning, to illuminate, to simplify, to clarify, to modify, to dignify, to dramatize, to persuade, and perhaps even to amuse. To design is to transform prose into poetry. Design broadens perception, magnifies experience, and enhances vision. Design is the product of feeling and awareness, of ideas that originate in the mind of the designer and culminate, one hopes, in the mind of the spectator. Design, as we shall see, is also an instrument of disorder and confusion. Design for deception is often more persuasive than design for good; seduction is one of its many masks.

Design is both a verb and a noun. It is the beginning as well as the end, the process and product of imagination. Like a huge onion with multiple layers, the more it is peeled, the more it reveals. Content is the raw material of design. Form, in turn, is the reorganization and manipulation of content. To form is to fix visual relationships in a given space, hence *form* and *plastic* are also synonyms for design. Design is the fusion of form and content, the realization and unique expression of an idea.[1] Design entails a part-whole relationship expressed in terms of facture, space, contrast, balance, proportion, pattern, repetition, scale, size, shape, color, value, texture, and weight. These are the means; unity, harmony, grace, and rhythm are desirable ends. (This list of means and ends has been cited so often that it has almost lost all meaning. However, these very considerations are what ultimately distinguish art from non-art, good design from bad design. Furthermore, perfection in design depends on the integration of all ingredients. Since such ingredients are inexhaustible, perfection is really unattainable.) Implicit in all this are inventiveness, intuition, judgment, and experience. There is no formula for good design; each problem is unique, as is each solution. Furthermore, the world of design is not utopian; solutions are often willful, arbitrary, or the product of endless compromise.

Some aestheticians reject the expression *form and content* in favor of *form and substance, idea,* or *preconception.*

"Roosters," said Picasso in 1944, "have always been seen, but seldom seen so well as in American weathervanes." Clearly, the designer of this sheet metal weathervane (circa 1800) was acutely sensitive to form. His business, however, was not design, nor did he have to explain or justify what he did. But for the designer who may have to explain, understanding the problems of form takes the place of a lot of babble and ambiguity.

2. Fernand Léger, "The Machine Aesthetic," *Functions of Painting* (New York, 1971), 52

Fernand Léger, in his splendid little book *Functions of Painting,* succinctly describes his ideas about form. "I consider plastic beauty in general to be completely independent from sentimental, descriptive, and imitative values. Every object, picture, architectural work, and ornamental arrangement has an intrinsic value that is strictly absolute, independent of what it represents."[2] Léger considered painting (and presumably design) as object rather than subject and as the priority of form over subject matter.

It is true that while aesthetic judgments are largely intuitive, it is the abstract (or formal) aspect of a work that takes precedence over other considerations. Yet when form (the abstract) not only predominates but is allowed to overshadow the content of a work, information goes astray, and the conflict between form and content remains unresolved. To see the abstract in the concrete and the concrete in the abstract is the essence of art making and appreciation.

The difference between *fine* and *applied* or *popular* art is not a difference of genre but a difference between two kinds of *formal qualities,* between good and bad, sensitive or insensitive to visual relationships — rhythm, contrast, proportion — and how these qualities, for example, separate Rembrandt from Norman Rockwell. In Rembrandt one is awed by *formal invention,* in Rockwell one is awed by *manual dexterity.* Considering such questions, one must be sensitive to the elusive qualities that so often affect one's perceptions when, for example, symbols are understood as the real thing, vagueness may be seen as subtlety, mawkishness as genuine feeling, faddishness as originality, and popularity as substance. Regrettably, the expressions *applied* and *popular* have a pejorative ring — the very words seem prejudicial, implying something inferior. The so-called primitive art of Africa or Mexico, for example, easily refutes this notion. That folk art is an art of and for the people does not in any way diminish whatever aesthetic value it may possess.

Right: This gouache as well as the watercolor on page 9 and the oil on page 10 were painted between 1952 and 1954 without benefit of smock or mahlstick. My perception was no different then from any other time I spent mulling over some design or typographic problem. This painting, with slight manipulation, could have been a poster, a mural, an illustration, or a book jacket.

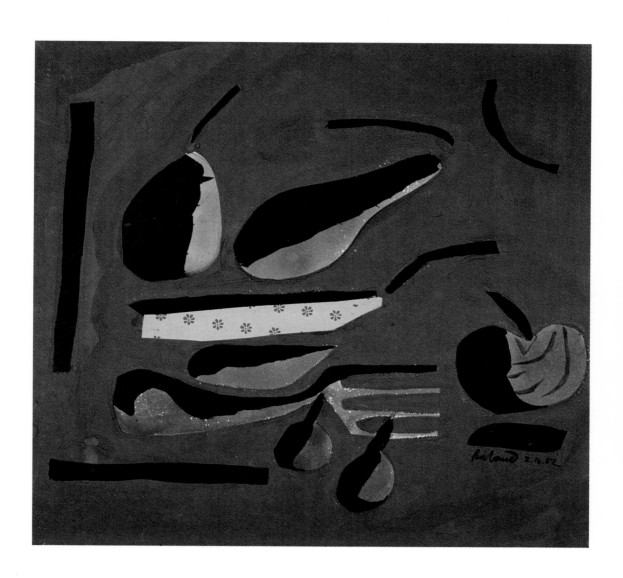

Everything possesses form of some kind, good or bad, pleasing or not: even decoration is a kind of form that has lost its way. There is no such thing as formlessness. Form and content are interactive; they are mutually dependent. Insofar as form manipulates content, content determines the nature of its manipulation. For constructivists or deconstructivists, no less than for conservatives or avant-gardists, there is good form and there is bad form. One cannot speak of form without implying value. Form may intensify, obfuscate, or even change meaning; it is never in a vacuum. Content, on the other hand, can never hide behind form: the more it tries the more it reveals itself as the absence of substance.

Design (aesthetic) judgments are based on two kinds of values, one symbolic or associative (extrinsic), the other formal (intrinsic). Symbolic values are those most of us use but often confuse with formal ones. These values are largely subjective and have little or nothing to do with design or art per se. Judgments are most often based on habit, hearsay, opinion, special meaning, prejudice, misunderstanding, conditioned learning — on social, psychological, political, financial, or even religious considerations. (To a visually unsophisticated pious person, for example, a bad copy of da Vinci's *Last Supper* seems no different from the original painting. His concern is piety, not art.) Intrinsic values involve aesthetics, the design itself (what it looks like, its visual quality), but not what it represents. Extrinsic judgments relate to content and meaning, intrinsic to *beauty,* which is more difficult to fathom because talent, expertise, taste, sensitivity, experience, and visual acuity must come into play. (What is meant by beauty here has nothing to do with fidelity to nature, beautiful nudes, or dazzling scenery; rather it has to do with fidelity to form [aesthetics]).

In painting and sculpture, as well as in architecture and design, problems of form have always been the same. Proportion is proportion; order, order. The effects of color are not dependent on medium, nor are the effects of scale, economy of means, harmony, rhythm, or even subject matter. Form is without bias. It is not based on time, place, nationality, school, or style. Picasso, speaking of Cubism, put it this way: "It is no different from any other school of painting; the same principles and the same elements are common to all."[3]

3. "Picasso Speaks," *The Arts* (May 1, 1923)

Poster for the Art Directors Club of New York, 1988.
The abstract and concrete join hands.

In another context he stated, "The art of the Greeks, of the Egyptians, of the great painters who lived in other times, is not an art of the past; perhaps it is more alive today than it ever was."

To understand the significance of form is to understand the similarities and differences among Masaccio (1401–1428), Rembrandt (1606–1669), Mondrian (1872–1944) on the one hand, and Norman Rockwell (1894–1978) on the other. It is also to understand the difference between the poetic and the prosaic, as well as the difference between a well-designed advertisement or machine and a badly designed advertisement or machine. In graphic design, *formal relationships* fix the appearance of things, while in industrial design they also help elucidate or camouflage their function.

4. Garry Wills,
Lincoln at Gettysburg
(New York, 1992)

Garry Wills, speaking of Lincoln's mastery of form in the Gettysburg Address, tells us how Lincoln "sensed from his own developed artistry, the demands that bring forth classic art — compression, grasp of the essential, balance, ideality."[+] The principles of form are universal and immutable. Emphasis on form, however, does not in any way diminish the role of substance, skill, emotional content, world view, or appropriateness. Form merely provides the spark without which content languishes.

There is nothing esoteric about art, but the language *of* art is not the language *about* art; one is visual, the other verbal. The ultimate question, *But is it art?* reveals not the power but the impotence of words and the limitations of reason. In art there are perceptions, opinions, speculations, and interpretation, but no proof. This is both its mystery and its magic.

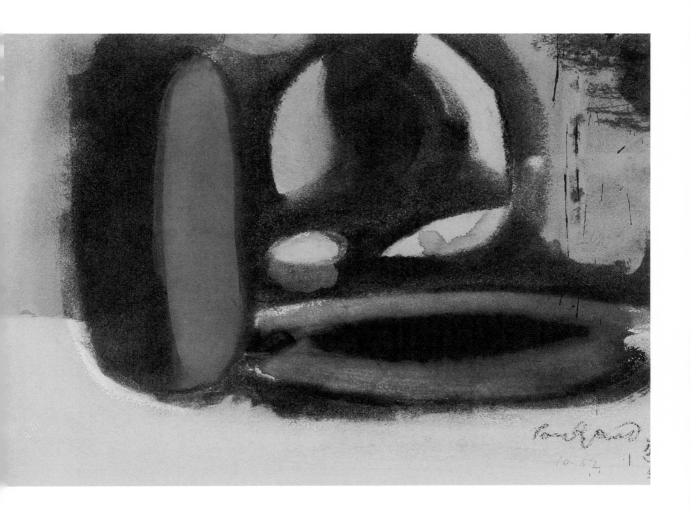

Watercolor, 1952.

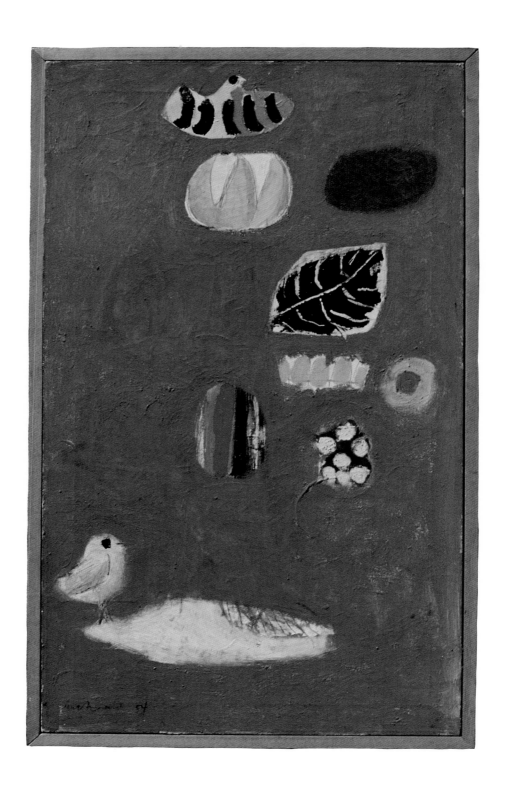

Oil on canvas, 1954. See caption on page 4.

Good Design Is Goodwill

Michelangelo, responding to the demands of Pope Julius II about the completion of the Sistine Ceiling, replied, "It will be finished when I shall have satisfied myself in the matter of art." "But it is our pleasure," retorted the pope, "that you should satisfy us in our desire to have it done quickly."[1] And it was not until he was threatened with being thrown from the scaffolding that Michelangelo agreed to be more expeditious. On the whole, however, the relationship between Michelangelo and the pope was reciprocal. Mutual respect, apologies, and ducats were the means of mediation.

Today the relationship between designer (painter, writer, composer) and management shares certain similarities with that of our distinguished protagonists. What has always kept the designer and client at odds is the same thing that has kept them in accord. For the former, design is a means for invention and experiment, for the latter, a means of achieving economic, political, or social ends. But not all business people are aware that, in the words of a marketing professor at Northwestern University, "Design is a potent strategy tool that companies can use to gain a sustainable competitive advantage. Yet most companies neglect design as a strategy tool. What they don't realize is that design can enhance products, environments, communications, and corporate identity."[2]

The expression *good design* came into usage circa 1940, when the Museum of Modern Art sponsored the exhibit "Useful Objects of American Design under Ten Dollars." The intention, of course, was to identify not just "good" design but the best, that which only the most skillful designer (trained or untrained) could produce. Over the years designers of both products and graphics have created an impressive collection of distinguished designs. Yet ironically, this body of good work makes one painfully aware of the abundance of poor design and the paucity of good designers. Talent is a rare commodity in the arts, as it is in other professions. But there is more to the story than this.

1. Giorgio Vasari, *Lives of the Most Eminent Painters, Sculptors and Architects* (1568), 3:1868

2. Philip Kotler and G. A. Rath, "Design: A Powerful but Neglected Strategy Tool," *The Journal of Business Strategy* (Fall 1984), 12

Right: This 19th century French pitcher, a clear example of good design by a good designer, was produced long before the expression good design was bandied about. The ornament was used by the early Greeks and was a conspicuous motif of the Secessionists and artists and architects of the Wiener Werkstätte (1903). "There is nothing new under the sun."

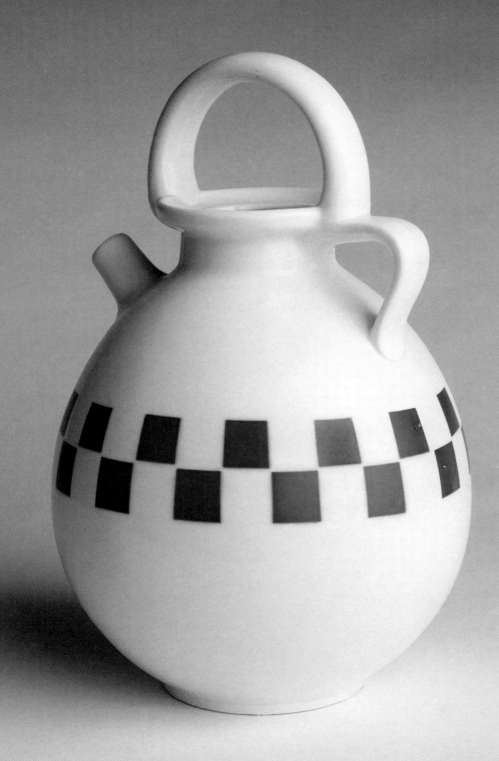

Westinghouse is building a remarkable craft, a free-roaming explorer
of the underseas. Unlike the famous bathysphere, which dangled at the end
of cables, *Deepstar* has no strings attached. She will rise, dive, turn and back
at will, self-propelled and independent. Her 3-man crew will be able to
set instruments, sample the bottom at depths of two miles, salvage, photograph,
and most of all, *explore* the vast oceanic world that has hidden itself so long from man.
Captain Jacques-Yves Cousteau, the undersea pioneer who created
the basic concept, is collaborating with Westinghouse on the vehicle. *Deepstar* will be equipped
with the controls, instruments, mechanical "hands" and everything else
needed for the deep swim. *You can be sure…if it's* Westinghouse

New Undersea Craft: Swims Deep, Carries Men

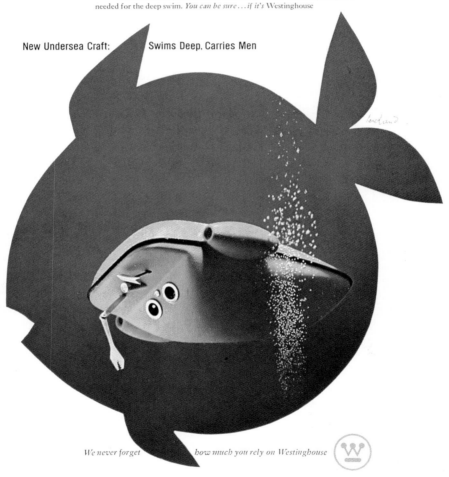

We never forget how much you rely on Westinghouse

Advertisement, Westinghouse, 1965.
Technology and nature join forces. Lines of type suggest water.

Even if it does not require extensive schooling, design is one of the most perplexing pursuits in which to excel. Besides the need for a God-given talent, the designer must contend with encyclopedic amounts of information, a seemingly endless stream of opinions, and the day-to-day problem of finding "new" ideas (popularly called creativity).

Yet as a profession it is relatively easy to enter. Unlike those of architecture and engineering, it requires no accreditation (not that accreditation is always meaningful in the arts). It entails no authorization from official institutions, as do the legal and medical professions. (This is equally true of other arenas in the business world, for example, marketing and market research.) There is no set body of knowledge that must be mastered by the practitioners. What the designer and his client have in common is a license to practice without a license.

Many designers, schooled or self-taught, are interested primarily in things that look good and work well; they see their mission realized only when aesthetics and practical needs coalesce. What a designer does is not limited to any particular idea or form. Graphic design embraces every kind of problem of visual communication, from birth announcements to billboards. It embodies visual ideas, from the typography of a Shakespearean sonnet to the design and typography of a box of Kellogg's Corn Flakes. What might entitle these items to the *good design* accolade is their practicability and their beauty, both of which are embodied in the idea of quality. The Bahlsen design (circa 1930) meets both goals admirably. "H. Bahlsen, the biscuit maker of Hanover, was a manufacturer who combined art and his work in the most thorough fashion."[3] He was one of those rare businessmen who believed that "art is the best means of propaganda."

3. H. K. Frenzel, editor,
Gebrauchsgraphik
(Berlin, January 1932), 2

Martel Schwichtenberg

printing the dirt

The editor of the Graphic Arts Production Yearbook (1950) was shocked
at seeing so little color on this four-color spread.

Good Design Is Goodwill

UCLABC DEFGHIJ KLMN●P QRSTUV WXYZ93

UCLA Summer Sessions 1993

University of California, Los Angeles
Los Angeles, California 90024
March 1993

Session A: June 28–August 6
Session B: July 19–August 27
Session C: August 9–September 17

Cover design, UCLA, 1993. One alphabet is worth a thousand pictures.

Good Design Is Goodwill

Design is a personal activity and springs from the creative impulse of an individual. Group design or design by committee, although occasionally useful, deprives the designer of the distinct pleasure of personal accomplishment and self-realization. It may even hinder his or her thought processes, because work is not practiced under natural, tension-free conditions. Ideas have neither time to develop nor even the opportunity to occur. The tensions encountered in original work are different from those caused by discomfort or nervousness.

The relationship that exists between the designer and management is dichotomous. On the one hand, the designer is fiercely independent; on the other, he or she is dependent on management for support against bureaucracy and the caprice of the marketplace. I believe that design quality is proportionately related to the distance that exists between the designer and the management at the top. The closer this relationship, the more likely chances are for a meaningful design. For example, the relationship between the designer and the chief executive of Bahlsen was, undoubtedly, very close. "With a very few exceptions, all the Bahlsen wrappers are the work of a woman artist, Martel Schwichtenberg. In a masterly manner she contrived to keep the designs up to their original high standards."[+]

Ibid., 11

Design is less a business than a calling. Many a designer's workday, in or out of the corporate environment, is ungoverned by a time sheet. Ideas, which are the designer's raison d'être, are not produced by whim nor on the spur of the moment. Ideas are the lifeblood of any form of meaningful communication. But good ideas are obstinate and have a way of materializing only when and where they choose — in the shower or subway, in the morning or middle of the night. As if this weren't enough, an infinite number of people, with or without political motives, must scrutinize and pass on the designer's ideas. Most of these people, in management or otherwise, have no design background. They are not professionals who have the credentials to approve or disapprove the work of the professional designer, yet of course they do. There are rare exceptions — lay people who have an instinctive sense for design. Interestingly, these same people leave design to the experts.

If asked to pinpoint the reasons for the proliferation of poor design, I would probably have to conclude, all things being equal, that the difficulties lie with: (1) management's unawareness of or indifference to good design, (2) market researchers' vested interests, (3) designers' lack of authority or competence.

Real competence in the field of visual communication is something that only dedication, experience, and performance can validate. The roots of good design lie in aesthetics: painting, drawing, and architecture, while those of business and market research are in demographics and statistics; aesthetics and business are traditionally incompatible disciplines. The value judgments of the designer and the business executive are often at odds. Advertising executives and managers have their sights set on different goals: on costs and profits. "They are trained," says Kotler, quoting a personnel executive, "in business schools to be numbers-oriented, to minimize risks, and to use analytical detached plans — not insights gained from hands-on experience. They are devoted to short-term returns and cost reduction, rather than developing long-term technological competitiveness. They prefer servicing existing markets rather than taking risks and developing new ones."

Many executives who spend time in a modern office at least eight hours a day may very well live in houses in which the latest audio equipment is hidden behind the doors of a Chippendale cabinet. Modern surroundings may be synonymous with work, but not with relaxation. The preference is for the traditional setting. (Most people are conditioned to prefer the fancy to the plain.) Design is seen merely as decoration — a legacy of the past. Quality and status are very often equated with traditional values, with costliness, with luxury. And in the comparatively rare instance that the business executive exhibits a preference for a modern home environment, it is usually the super modern, the lavish, and the extremely expensive. Design values for the pseudo-traditionalist or super-modernist are measured in extremes. For the former it is how old, for the latter how new. Good design is not based on nostalgia or trendiness. Intrinsic quality is the only real measure of good design.

Old and amusing artifacts like this Victorian mask serve as both a source of inspiration and a friendly letter-drop. It demonstrates as well that the humorous and the utilitarian are not mutually exclusive, and that only the pompous and the uninformed see humor as a problem.

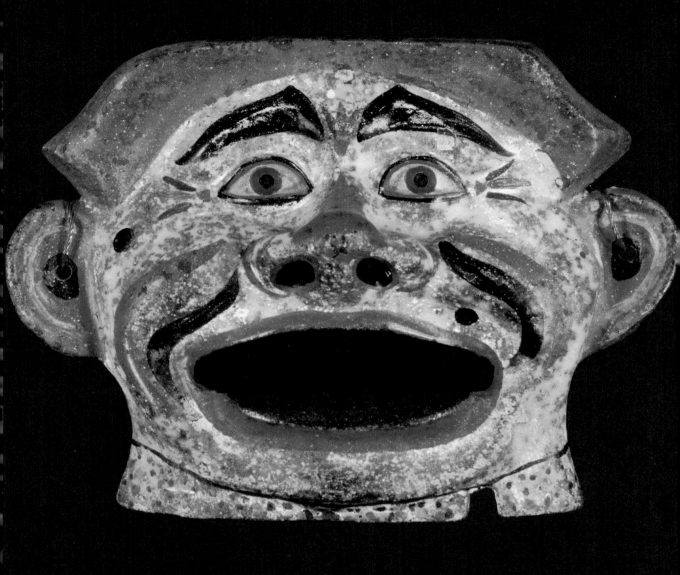

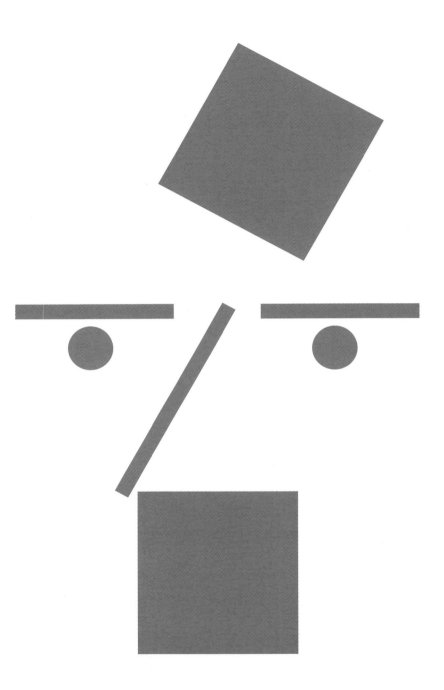

Caricature depends on compression and grasp of essentials. Hitler or Groucho?
Two squares arranged in a certain order...the power of geometry.

In some circles art and design were, and still are, considered effeminate, something "removed from the common affairs of men." Others saw all artists "performing no useful function they could understand."[5] At one time, design was even considered a woman's job. "Let men construct and women decorate,"[6] said Benn Pitman, the man who brought new ideas about the arts from England to the United States in the 1850s. To the businessman whose mind-set is only the bottom line, any reference to art or design is often an embarrassment. It implies waste and frivolity, having nothing to do with the serious business of business. To this person, art belongs, if anywhere, in the home or museum. Art is painting, sculpture, etching; design is wallpaper, carpeting, and upholstery patterns.

"Art," says Henry James, "in our protestant communities, where so many things have got so strangely twisted about, is supposed in certain circles, to have some vaguely injurious effect on those who make it an important consideration.... It is assumed to be opposed in some mysterious manner to morality, to amusement, to instruction."[7]

To many designers, art/design is a cultural mission in which life and work are inseparable. Clean surfaces, simple materials, and economy of means are the designer's articles of faith. Asceticism, rather than "the good life," motivates good designers — in keeping with the ideals of the modern painters, architects, and designers of the early part of this century, and with the beliefs, as expressed later by Edgar Kaufman: good design is a "thorough merging of form and function and an awareness of human values, expressed in relation to industrial production for a democratic society."[8]

Not just good design but the implication of its modernity needs to be stressed. Le Corbusier, the great and influential architect and theorist, commented: "To be modern is not a fashion, it is a state. It is necessary to understand history, and he who understands history, knows how to find continuity between that which was, that which is, and that which will be."[9]

. William Gaunt,
The Aesthetic Adventure
(New York, 1967), 8

. Robert B. Stein,
"The Aesthetic Craze,"
Art News
(December 1986), 105

. Henry James,
"The Art of Fiction,"
The House of Fiction
(New York, 1941), 27

. E. Kaufman,
What Is Modern Design?
(New York, 1950), 9

. William J. R. Curtis,
Le Corbusier: Ideas and Forms
(New York, 1986), 224

The market researcher, on the other hand, whose concern is primarily financial, has less lofty ideals. He or she is interested in facts and opinions — even if some of those facts may not be so factual, and some of those opinions may be irrelevant. Ironically, the marketer is really a professional who uses nonprofessionals for advice. "Many managers," says the author of *The Design Dimension*, "are heavily oversold on what market research can do…they use it as a decision substitute, instead of for decision support.…The predictive abilities of market research are innately limited, because it can only probe attitudes which are often a surprisingly poor guide to actual behavior.…Even if the research is well and objectively constructed — and there are plenty of horror stories of loaded questions, poor sampling techniques and other methodological errors — market research can probe the human psyche to only a limited degree of reliability."[10]

10. Christopher Lorenz, *The Design Dimension* (London, 1986), 32

In a survey made by an Italian department store, La Rinascente, results of consumer polls were surprising. A group of potential customers were asked to choose which, among an array of different colored glasses, they preferred. With few exceptions, they all chose red. Dozens of red glasses were quickly put up for sale. Not a single glass was sold. To put it bluntly, this survey does cast some doubt on the role of consumer testing, or on the manner in which tests are conducted.

How reliable, then, are market research polls? Sometimes they are interesting, but when opinions are vastly divided they can be bewildering. In the introduction to *The House of Fiction*, the editor speaks about such phenomena: "The observers might watch the same show, but what they saw was never the same; one would see more, while the other saw less; one would see black, while the other saw white; one would see big, while the other saw small; and, not least, one would see coarse, while the other saw fine."[11] This may sound like a plea to end all such investigations. In terms of providing visual clues — that a marketer may or may not find significant — it could be quite useful. However, designers almost always do their own "research." They never work in a vacuum. Even if they rant and rave about the inadequacies of market research, they may be conducting their own private inquiries by personal interview or consulting their own resources. They may ask questions, or talk directly to users or passersby, getting their ideas and studying their surroundings. To be sure, it is easier

11. Henry James, "The Art of Fiction," *The House of Fiction* (New York, 1941), 12

to elicit information about functional problems than about those dealing almost exclusively with matters of form or taste. Industrial designers, to whom the first part of this statement applies, would more likely find research useful than would graphic designers. "Does it work?" is easier to respond to than "How do you like the typeface?" But there are occasions when graphic designers can find research quite helpful. Holding up a sketch of the familiar United Parcel Service logo, I asked my seven-year-old daughter, "What's this, Cath?" to which she quickly responded, "That's a present, Daddy." Formal research could hardly have been more useful or more educational.

When should market research be used? In the area of corporate identity, for example, the need for research, other than to satisfy one's curiosity, is questionable. How can one research subjects as arguable as *novelty, originality,* or *uniqueness*? And how can one be certain that results will not be manipulated, questions will not be biased, and negative responses will not be hidden?

Might the IBM logo have looked like this (opposite) had it been subjected to market polling?

I am sure this candidate would have earned a fair number of votes. But what could a researcher have asked about the existing logo? What do you think of this design? Does it say anything about computers? What kind of business does it suggest? The professional can concoct more suitable queries. But what possible responses could one have expected? "I like it. I don't like it. It's too simple. It's too complicated. It reminds me of a candy cane, a barber pole, a prisoner's suit, a zebra," and so on. What possible use could such information have been to anyone? "I don't like it," from public opinion polls, is very often enough to put an end to any design. Commenting on this phenomenon, Henry James writes, "Nothing, of course, will ever take the place of 'liking' a work of art or not liking it: the most improved criticism will not abolish that primitive, that ultimate test."[12]

12. *Ibid.,* 37

That there are as many opinions as there are people is no revelation, but how does one reconcile the many different points of view that research polls generate? Predictability and dependability, so useful in helping to make judgments, are possible only when there is certainty, but where is certainty among a babble of opinions? Little wonder then that researchers consider themselves lucky if they succeed in accomplishing their objectives about 50 percent of the time.

Often the problem with research data is that the data themselves are seen as creativity, as evidence, and not as possible clues for conceptualization. If, for example, research reveals that type size or color is a factor in product recognition, as often as not raucous color schemes and offensive letter forms are chosen simply out of expedience or ignorance. If taste plays any role in choosing, it is often the taste of the investigator, or his wife, or his secretary that is decisive. The problem, I believe, does not lie in collecting data, but in interpreting and synthesizing that data. I once asked an advertising executive his opinion of an advertisement that had only recently been market tested. "I'm not the target audience; I cannot get emotionally involved," was his quick response. This was another way of saying, "Sorry, it's not our policy to comment on that." Why? "It would be inappropriate." (The bureaucrat's all-purpose excuse for not doing anything.)[13] On further questioning, the advertising man replied, "But the ads scored very well," about which one could only speculate how much better they might have scored had they been well designed; or even if they had scored only as well, at least they might not have contributed to the problems of visual pollution.

One wonders how so many poorly designed advertisements ever reach the point of being tested. Does this say something about the effectiveness of market testing or about the sensitivity of pollsters and their advertising agencies, their taste, and their appreciation of good design? The fact that so many poorly designed advertisements, packages, and products exist points to those who are unmindful of the place and value of good design.

13. William Safire, "On Language," *The New York Times* (February 15, 1987)

Right: Poster, 1980, Tri Arts Press. Given the right questions, this picture might even pass a market survey test.

The fusion of marketing research opinions with relevant aesthetic considerations is best accomplished by those professionals whose business it is to be imaginative. "Imagination is not to be divorced from the facts. It is a way of illuminating the facts."[14] The imagination takes the slightest hints and turns them into revelations.

14. A. N. Whitehead, "Universities and Their Function," *The Aims of Education* (New York, 1952), 97

It is the professional's job to distinguish between "moods and facts, enthusiasm and thoughtfulness,"[15] between things symbolic and things real. The mere manipulation of opinions by marketers cannot replace imaginative interpretation. Things look as they do because the right or wrong people are making decisions. The marketer who understands and is sympathetic to the design process can help to make the right decisions.

15. G. B. Shaw, *Man and Superman* (New York, 1947)

It is the place of marketing to supply information, and it is the place of the designer, with the marketer's cooperation, to interpret that information. Literal interpretation produces stereotypes; creative interpretation produces surprises — that competitive distinctiveness that business seeks. In his book *The Design Dimension*, the author comments, "Though industrial designers frequently can and do substitute for the absence of marketing imagination, in more companies the most potent force for imaginative marketing and product strategy is a real partnership between marketing and design."[16]

16. Christopher Lorenz, *The Design Dimension* (London, 1986), 147

Blind acceptance of the results of market research and opinions based exclusively on conditions of the past can be destructive in many ways. It tends largely to discourage initiative and exploration by the designer. It may even be regressive in that it pins future strategy on the opinions of the past. "You cannot measure the future on the basis of the past," said the British philosopher Karl Popper, "the past is only an indication, not an explanation." It can therefore never be really original. It steps backward, not forward. Its conclusions are determined not on the opinions of professionals but on those of the public, whose attitudes, even if predictable, are usually vague and often more emotional than reasonable. Further, the public is more familiar with bad design than good design. It is, in effect, conditioned to prefer bad design, because that is what it lives with. The new becomes threatening, the old reassuring.

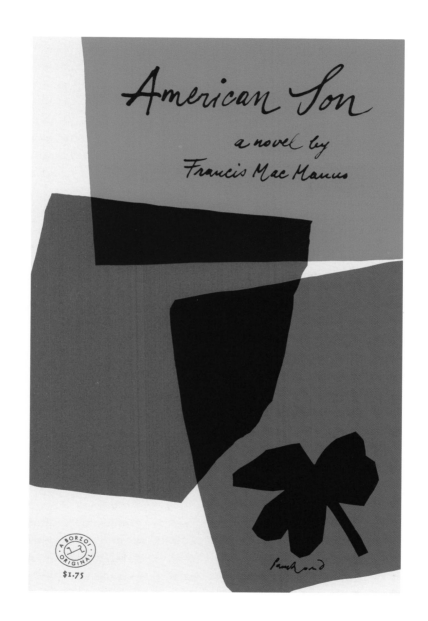

Cover design, Knopf, 1954. Three colors overlapping create a fourth color —
a lesson in economy.

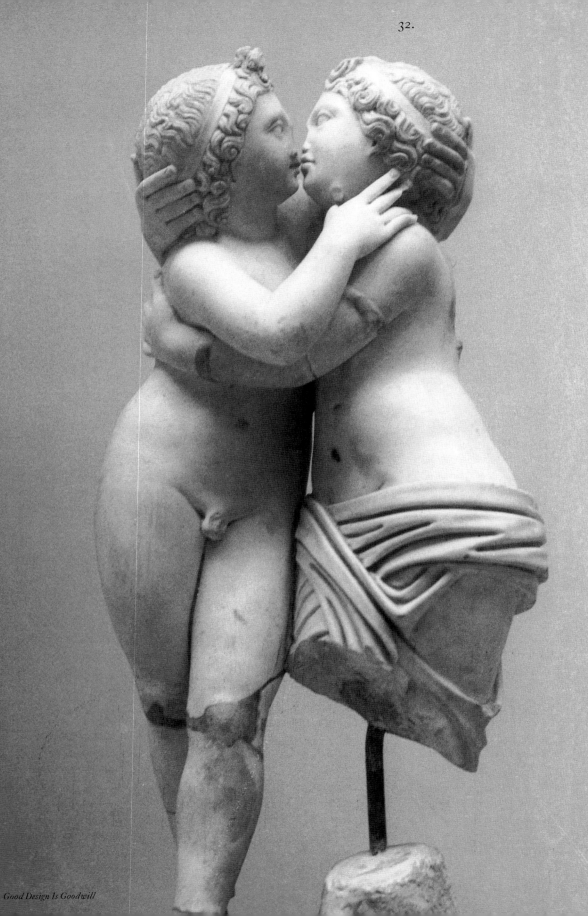

"Good design is good business," said Tom Watson. But it is equally true that any design, even bad design, can be good business. In a *New York Times* article entitled "Designer Packages Sell," the writer describes how a package for cheese was redesigned in order to improve product identity. Some of the criticism of the original package seemed valid — such as insufficient emphasis on the maker's name. The designer went to a lot of trouble "using various designs and colors. Each alternative went through a testing process...visibility from different angles, and under different lighting conditions." Other than creating a false sense of security, there seems to have been little reason for all this elaborate testing, especially when it yielded a package that was essentially less interesting than the one it replaced. Not only were all the good features of the previous design abandoned, such as an old horse and carriage mark and an elegant typeface, but type designs of many different weights, sizes, and colors, undistinguished both in style and arrangement, were substituted. Two bands of color, which can only be described as clichés, were also added.

No doubt this new design is an improvement in visibility and shelf prominence, but is it an improvement in design? If this new design means more sales, how much might a more distinctive design — one in which fine typography and imaginative ideas and not just visibility and sales were a criterion — have helped? To have missed the chance to design a package that is distinctive as well as visible is regrettable. That it could have been competitively advantageous, and also provide a moment's delight, is equally regrettable.

Yet to deny the usefulness of market research is simply to deny the usefulness of facts. Even if these "facts" seem trivial, they may, in the absence of other inspiration, provide design clues. Market research can be useful in gauging needs and practical requirements, such as shelf visibility, competitive activities, and legibility of nomenclature. In product design, such information dealing with ergonomics is even indispensable. On the whole, though, market research is without value unless judiciously applied.

Left: Imagine what could have happened had this sculpture been subjected to market research.

The problems a designer is likely to face in business relations depend a great deal on how well informed, genuinely interested, and experienced a client is. Managers responsible for design are usually chosen not for their eye, nor for their impeccable taste, but for their administrative skills. Few understand the intricacies of design or even the role, beyond the obvious, that design and designers play.

Most see the designer as a set of hands — a supplier — not as a strategic part of a business. Their background is primarily marketing, purchasing, or advertising; only incidentally or accidentally are they connoisseurs of design. It is their uninformed, unfocused preferences or prejudices, their likes or dislikes, that too often determine the look of things. Yet they may not even be discriminating enough to distinguish between good and bad, between trendy and original work, nor can they always recognize talent or specialized skills. They have the unique privilege, but not necessarily the qualifications, to judge design.

Managers responsible for the administration of design may spend endless hours at meetings allegedly about design that take up marketing, production, and administration problems as if they were design problems. Whether the participants understand the nature of the problems, or the implication of design, is questionable. If quality, for example, is the subject for discussion, it is dealt with only as an *abstraction*, with participants *assuming* the others understand what is being discussed, when in fact no one can be sure. Since perception is so intimately a part of taste and design, the experienced designer might possibly point the way to meaningful solutions and smooth the path for an administrator's needs.

Right: Poster, UCLA, 1990: a study in contrasts.

UCLA
Extension

Winter
Quarter

begins
January 6
1990

University Center
Dedication
April 25, 1989
University
of Hartford

William H. Mortensen Library
Harry J. Gray Conference Center
Helen Buckley Gray Communication Center
Museum of American Political Life
Joseloff Gallery
University Bookstore
The 1877 Club

Poster, University of Hartford, 1989. Abstraction turns into celebration.

The designer is not always right. The researcher is not always wrong. Profit is not always the motive; market research, whatever its outcome, should never be used as a good excuse for bad design — in the same sense that good design should never be used to promote a bad product.

Design no less than business poses ethical problems. A badly designed product that works is no less unethical than is a beautiful product that doesn't. The former trivializes the consumer, the latter deceives him. Design that lacks ideas and depends entirely on form for its realization may possess a certain kind of mysterious charm; at the same time it may be uncommunicative. On the other hand, design that depends entirely on content will most likely be so tiresome that it will not compel viewing. "Idea and the form," says James, "are the needle and thread, and I never heard of a guild of tailors who recommended the use of thread without the needle or the needle without the thread."[17] Good design satisfies both idea and form, the needle and the thread.

Henry James,
"The Art of Fiction,"
The House of Fiction
(New York, 1941), 40

A company's reputation is very much affected by how the company appears and how its products work. A beautiful object that doesn't work is a reflection on the company's integrity. In the long run, it may lose not only customers but their goodwill. Good design will function no longer as the harbinger of good business but as the herald of hypocrisy. Beauty is a by-product of needs and functions. The Barcalounger is extremely comfortable, but it is an example of beauty gone astray. A consumer survey that would find such furniture comfortable might find it to be beautiful as well, merely because it is easy to conclude that if something works it must also be beautiful and vice versa. Ugliness is not a product of market research but of bad taste, of misreading opinions for analysis and information for ideas.

Poster, PDR, 1985: "What would life be if we had no courage to attempt anything?"
(Vincent van Gogh)

8. Joan Campbell,
"The Founding of the Werkbund,"
The German Werkbund
(New Jersey, 1978), 14

In 1907 the German Werkbund was formed, an organization whose purpose it was to forge the links between designer and manufacturer. It was intended to make the public aware of the folly of snobbery and to underscore the significance of the "old ideals of simplicity, purity and quality." Its aims were also to make producers aware of "a new sense of cultural responsibility, based on the recognition that men are molded by the objects that surround them."[18]

From little buckslips to big buildings, the visual design problems of a large corporation are virtually without end. It is in the very solution of these problems — well-designed advertisements, packaging, products, and buildings — that a corporation is able to help shape its environment, to reach and to influence the taste of vast audiences. The corporation is in a singularly strategic position to heighten public awareness. Unlike routine philanthropic programs, this kind of contribution is a day-to-day activity that turns business strategy into social opportunity and good design into goodwill.

Left: Recruiting poster, Yale University, 1988.

Is photography art? The photo above and the one on page 38 of an old sign were both taken some years ago. Whether they deserve the accolade art is an aesthetic question. Both pose the same philosophical problems a typographic design, poster, or painting does.

Intuition and Ideas

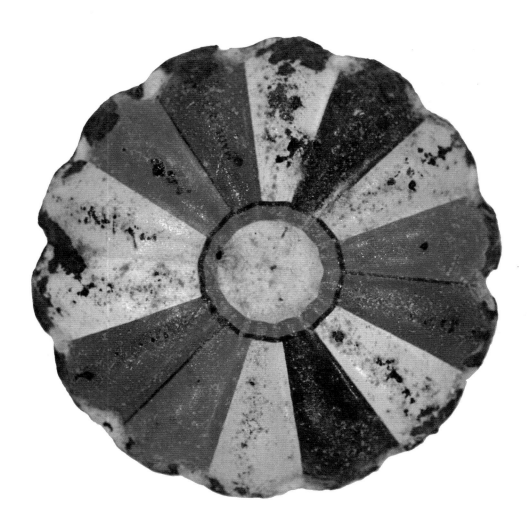

This rosette, an enlargement of a toy roundel, becomes a valid illustration
for the abstract idea of intuition merely by being so dubbed.

1. A. N. Whitehead,
Adventures of Ideas
(New York, 1933), 228

2. Henri Bergson,
"Philosophical Intuition,"
The Creative Mind
(New York, 1946), 109

3. K. F. Wild,
Intuition
(Cambridge, 1938), 2

4. Immanuel Kant,
Encyclopedia of Philosophy
(New York, 1967), 4: 204

5. Wild, *Intuition*, 221

"All knowledge," said Whitehead, "is derived from and verified by direct intuitive observation."[1] But such observation provides little comfort for those who need the security of down-to-earth proof. Judgments that lack the support of the opinion makers or of research findings are generally suspect. Some of the reasons, it seems, that intuition has not won accolades are that it is only vaguely understood and virtually impossible to pin down. "What is this intuition?" asks Henri Bergson. "If the philosopher has not been able to give the formula for it, we certainly are not able to do so."[2]

The semantics of intuition are, for the most part, bewildering. One can perhaps understand intuition more easily by intuitive judgment than by definition, although "it is as rich in suggestion as poor in definition."[3] In its broadest sense, we are told, intuition means "immediate apprehension." *Immediate* may be used to signify the absence of inference, conceptualization, causes, symbols, thoughts, justification, or definition. *Apprehension* may include such unrelated states as sensation, knowledge, and mystical rapport.[4]

"Though the characteristics of knowing, of immediacy, of truth, are all present, the quality which is especially present to the mind when using the word in any of these senses is that of inexplicability."[5] So there is really no one definition for intuition. For the sake of this chapter we can settle on: a flash of insight. Intuition cannot be willed or taught. It works in mysterious ways and has something in common with improvisation. It has nothing to do with intentions, or with programming. It simply happens — an idea out of the blue — characterized sometimes by surprise, elation, and a release of tension. Intuition is conditioned by experience, habit, native ability, religion, culture, imagination and education and, at some point, is no stranger to reason.

6. William James,
"Instinct,"
Psychology Briefer Course
(New York, 1945), 398

"There is no antagonism between instinct and reason," said William James.
"Reason per se can inhibit no impulses....Reason may, however, make an
inference which will excite the imagination so as to let loose the impulse the
other way."[6]

Intuition does not always generate great ideas. Getting into a bathtub and
arriving at the displacement of water theory (Archimedes) is uncommon evi-
dence of intuition. Most intuitive acts are uneventful daily activities. When great
accomplishments are cited, they are usually the achievements of great minds.

7. B. F. Skinner,
"Causes and Reasons,"
About Behaviorism
(New York, 1974), 135

"Newton could hold a problem in his mind for hours and days and weeks
until it surrendered to him its secret. Then being a supreme mathematical tech-
nician, he could dress it up how you will, for the purposes of exposition.
But it was his intuition which was preeminently extraordinary."[7]

The question is really less a matter of *experiencing* than of *listening* to one's
intuitions, following rather than dismissing them. It is also the quality of one's
intuitions that matters — whether they are banal (as most are) or exciting (as
very few are). The intuitive process can also be seen as an inhibiting one. "What
a strange force," reflects Henri Bergson, "this intuitive power of negation is...it

8. Henri Bergson,
"Philosophical Intuition,"
The Creative Mind
(New York, 1946), 110

forbids."[8] This phenomenon may occur, for example, when a good idea is
abandoned because of doubt, fear, confusion, superstition, prejudice, or habit.

The words intuition, instinct, impulse, hunch, and insight, as used in this
chapter, are interchangeable. Instincts, however, are commonly understood to
refer to lower animals, and intuition to man.

The ability to intuit is not reserved to any special class of individuals, although many painters, writers, designers, dancers, or musicians believe that this ability is something special, something God-given. The intuitive faculty does, however, seem more pervasive in matters of aesthetics than in those of daily routine. Except in a most general sense, one cannot prove the validity of color, contrast, texture, or shape. Compliance with all the laws and systems of form, restraint, and proportion will not provide proof of the soundness of a work of art, nor guarantee its coming to fruition. This is one of the reasons it is so difficult to understand or teach art and why countless books on art are mere inventories rather than meaningful explanations. Even the brilliant exposition of historians such as Roger Fry, André Malraux, or Rudolf Wittkauer, however inspirational, however compelling, cannot directly generate great or even good works.

Without regard to available systems (e.g., the Golden Section, DIN proportions, typographic grids), the designer works intuitively. This is something about which one is often confused. No system of proportion, color, or space articulation can possibly insure exceptional results. Very often a system is used merely as a crutch, a kind of rabbit's foot or a good luck charm, regardless of need. A system can be applied either intuitively or intentionally, interestingly or tediously. There is always the element of choice, sometimes called good judgment, at others good taste.

Aside from practical considerations, in matters of form the typographer must rely on intuition. How else does one select a typeface, decide on its size, line width, leading, and format? The alternatives are to repeat one's previous performances, to imitate what others have done, or simply to make arbitrary decisions.

The resentment that creative people sometimes harbor against research, it seems to me, is largely the resentment of those who make decisions intuitively, without the "benefit" or interference of so-called reasonable arguments.

Opinion polls, in which intuition most likely plays some role, are, ironically, often used to combat the intuitive notions of creative designers and writers. It is fairly safe to speculate that most good ideas in the field of communication take shape unconsciously. Nor would it be wrong to assume that some of the best ideas in any field are in some way, at some point, intuitively perceived. "Think Small," so effectively exploited in Volkswagen advertisements, seems unquestionably an ingenious idea intuitively generated. It is a contradictory statement that evokes its opposite: Think Big. Mies van der Rohe's "less is more" is similarly effective because it involves the spectator's sense of irony.

The following playful exercise is an effort to bring the question of intuition down to earth; it may help to unravel some of its mysteries. The game involves the creation of a recognizable image out of a few scattered lines (below). This stimulus pattern turns out to be a simple demonstration of the intuitive process.

Warda Geismar

The idea of the game is to translate these lines into a recognizable image without rearranging the lines in any way. My immediate reaction to these rather uninspiring squiggles was indifference. Some time later, however, as if out of the blue, the face of this clown (opposite) appeared.

Here is a lesson in contrasts: black lines, colored dots (red, yellow, blue). By juxtaposition these elements are transformed into a lively abstraction suggestive of a clown. It is possible, of course, to make the facial features more descriptive merely by adding a little triangular cap, but simplicity and restraint are equally important — a lesson not only in economy but in appropriateness to a particular problem. This game demonstrates the role of intuition in achieving interest where there was none, a perplexing situation that confronts the designer every day.

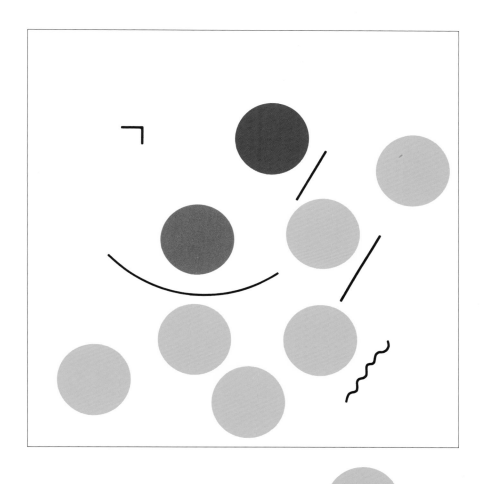

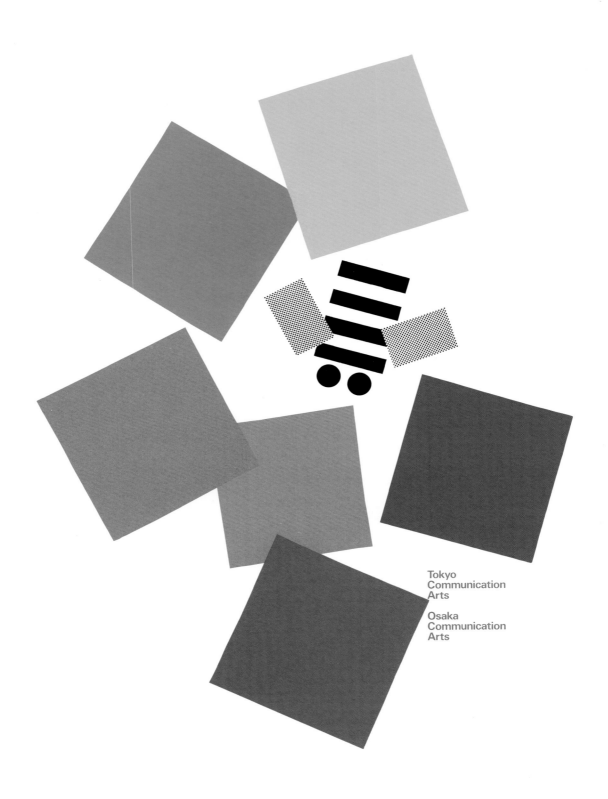

Tokyo
Communication
Arts

Osaka
Communication
Arts

Poster, Tokyo and Osaka Communication Arts, 1991

The arrangement of colored squares in the poster at left provides ample room for intriguing metaphors. What do these squares mean? The spectator becomes involved in an absorbing riddle; resolving the riddle is a source of satisfaction. The rose, as depicted in the poster on the following page, though more common-place, sets up a contrasting relationship with the stylized bee, which is engrossing. Choosing among different possibilities is often a bewildering experience. The dilemma of choosing between a metaphoric and a literal depiction is one commonly faced by the designer and settled intuitively if not arbitrarily. If a design is striking enough, it is not always necessary to explain it. Explanations sometimes obscure more than they reveal.

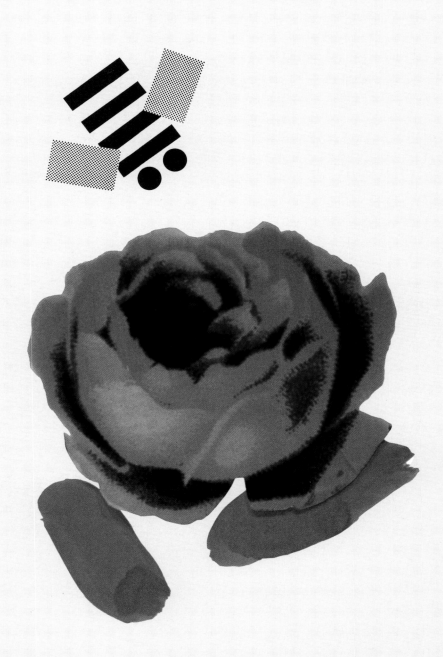

Sketch for poster shown on page 50.
This idea sets up a relationship between the real and the stylized.

Logos…Flags…Street Signs

Some thoughts and some despair about the design of a logo.

"It reminds me of the Georgia chain gang," quipped an IBM executive when he first eyed the striped logo. The Westinghouse insignia was greeted similarly when it was first shown in 1960: "This looks like a pawnbroker's sign." How many exemplary works have gone down the drain because of such pedestrian fault-finding? And how many good designs became bad designs as a consequence of mindless dabbling on the part of clients with little or no understanding of visual logic?

There is no accounting for people's perceptions. Some look at a logo, or any other example of visual design, as if it were a Rorschach inkblot. Others look without seeing either the meaning or even the function of a logo. It is perhaps this sort of myopia that prompted ABC TV to toy with the idea of "updating" their 1962 logo. They realized their folly only after a market survey revealed high audience recognition of the long-lived symbol. This is not to say that a well-established logo is necessarily a good one. Rather, in determining the intrinsic value of a logo, *quality*, not *vintage*, is the critical factor.

The problem of habit warrants serious thought. When a logo that has been around for a long time is altered — in design or color — it comes as a bit of a shock to those familiar with the original. Similarly, if one is habituated to a red fire engine a yellow or green one would be considered an aberration.

There are as many reasons for designing a new logo, or updating an old one, as there are opinions. The belief that a new or updated design will, like a talisman, magically turn around any business is not uncommon. A redesigned logo may have the advantage of implying something new, something improved — but this boost is temporary unless the company lives up to these claims.

Right: The Egyptian hieroglyph (3700 B.C.), the model for a well-designed logo, cannot be deemed old fashioned. The Egyptians invented geometry. The language of geometry is timeless and is based on points, lines, and planes; its tools are the compass and the straight edge.

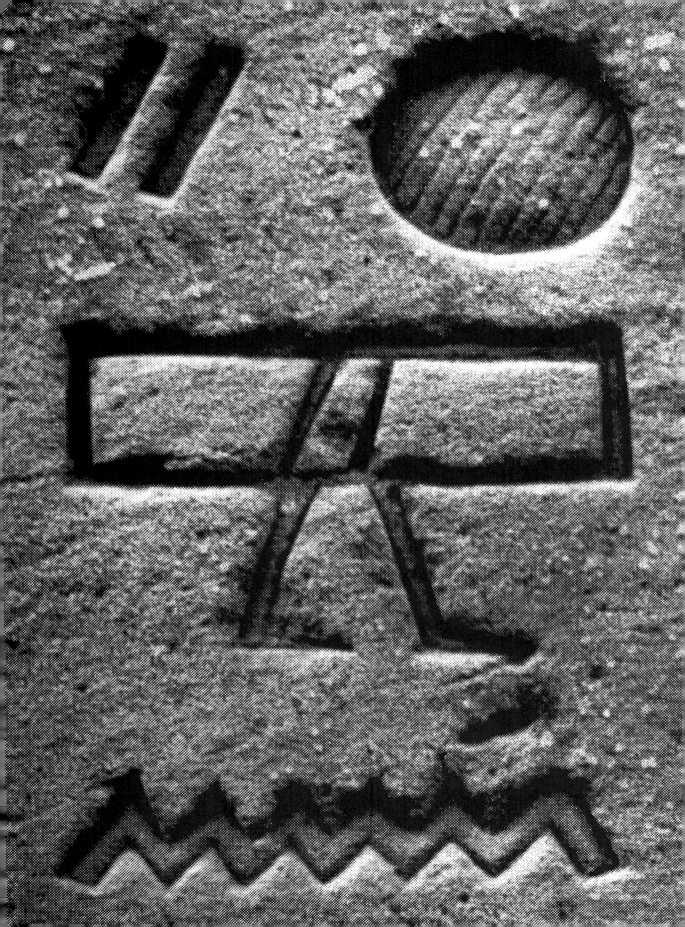

Sometimes a logo really *needs* redesigning because it is ugly, inappropriate, or old fashioned. But more often the redesign is undertaken merely to feed someone's ego, to satisfy a CEO who does not wish to be linked with the past, or because it's the thing to do.

In the other camp are those opposed to the idea of arbitrarily changing a logo, those who would "leave it alone" for reasons sometimes wise, more often superstitious, occasionally nostalgic, or at times even trepidatious. Not long ago, I offered to make some minor adjustments to the 1961 UPS logo. This offer was unceremoniously turned down, even though compensation played no role. If a design can be refined without disturbing its identity, it seems reasonable to do so. A logo, after all, is an instrument of pride and should be shown at its best. If in the business of communications, "image is king," the essence of this image, the logo, is the jewel in its crown.

Here is what a logo is and does:
A logo is a flag, a signature, an escutcheon, a street sign.
A logo does not sell (directly), it *identifies.*
A logo is rarely a description of a business.
A logo derives its *meaning* from the quality of the thing it symbolizes,
 not the other way around.
A logo is *less* important than the product it signifies; what it represents is more
 important than what it looks like.
The subject matter of a logo can be almost anything.

A logo appears in many guises: a signature is a kind of logo, so is a flag. The French flag, for example, and the flag of Saudi Arabia are aesthetically appealing symbols. One happens to be pure geometry, the other a combination of Arabic script and an elegant saber — two diametrically opposed visual concepts, yet both function effectively. Their appeal, however, is more than a matter of aesthetics. In battle, a flag can be a friend or foe. The ugliest flag is beautiful if it happens to be yours in victory. "Beauty," they say, "is in the eye of the beholder," in peace or in war, in flags or in logos. We all believe *our* flag the most beautiful; this tells us something about logos.

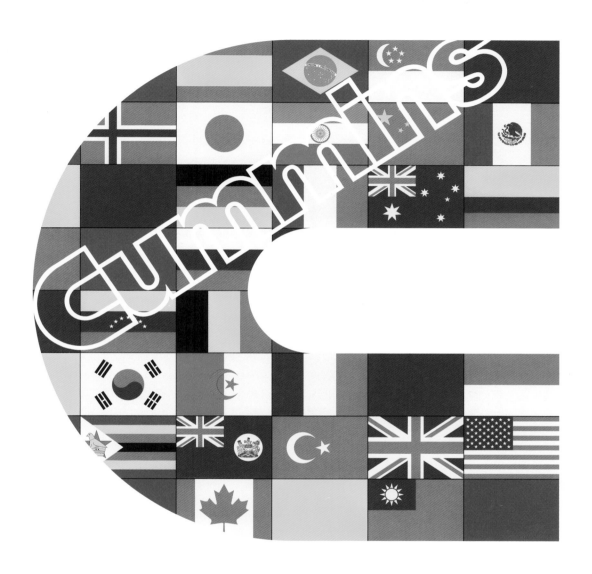

Logo and cover design, Cummins Engine Company, 1973/1991.
A logo that can accommodate different backgrounds must be simple in design.

A street sign is a kind of logo. Trying to locate an unfamiliar street that has no marker is a bewildering experience. Whether the sign is beautiful or ugly, serif or sans, only the name matters. A logo and a street sign have this in common — the need to be identified.

Should a logo be self-explanatory? It is only by association with a product, a service, a business, or a corporation that a logo takes on any real meaning. It derives its meaning and usefulness from the quality of that which it symbolizes. If a company is second rate, the logo will eventually be perceived as second rate. It is foolhardy to believe that a logo will do its job immediately, before an audience has been properly conditioned. Only after it becomes familiar does a logo function as intended; and only when the product or service has been judged effective or ineffective, suitable or unsuitable, does it become truly representative.

Logos may also be designed to deceive; and deception assumes many forms, from imitating some peculiarity to outright copying. This is particularly noticeable when certain characteristics of a logo of business X are incorporated in a logo of business Y. Design is a two-faced monster. One of the most benign symbols, the swastika, lost its place in the pantheon of the civilized when it was linked to evil, but its intrinsic quality remains indisputable. This explains the tenacity of good design.

The principal role of a logo is to identify, and simplicity is its means. A design that is complex, fussy, or obscure harbors a self-destructive mechanism. No amount of literal illustration will do what most people imagine it will do. This will only make identification more difficult and the "message" more obscure. A logo, primarily, says who, not what, and that is its function. *Its effectiveness depends on* distinctiveness, visibility, adaptability, memorability, universality, and timelessness. Most of us believe that the subject matter of a logo depends on the kind of business or service involved. Who is the audience? How is it marketed? What is the media? are some of the considerations. An animal symbol might suit one category; it could, at the same time, be anathema in another.

Logo, Pastore DePamphilis Rampone, 1987, Typesetters and Printers.
Logos need not be hand-lettered. A good typeface is often more appropriate.
It is not the typeface but how it is used that matters.

IBM identification, 1985. Design, like olives, takes getting used to.

Numerals are possible candidates — 747, 7-Up, 7-11 — and so too letters, which are not only possible but most common. Surprising to many, the subject matter of a logo is of relatively little importance, and even appropriateness of content does not always play a significant role.

This does not imply that appropriateness is undesirable. It merely indicates that a one-to-one relationship between a symbol and what is symbolized is very often impossible to achieve and, under certain conditions, objectionable. Ultimately, the only mandate in the design of logos, it seems, is that they be distinctive, memorable, and clear.

The Mercedes symbol, for example, has nothing to do with automobiles, yet it is a great symbol, not because its design is great but because it stands for a great product. The same can be said about apples and computers, about Tiffany and turquoise blue. Few people realize that a *bat* is the symbol of authenticity for Bacardi Rum; yet Bacardi is still being imbibed. Lacoste sportswear, for example, has nothing to do with alligators (or crocodiles), and yet the little green reptile is a memorable and profitable symbol. What makes the Rolls Royce emblem so distinguished is *not* its design (which is commonplace), but the *quality* of the automobile it represents. Similarly, the signature of George Washington is distinguished not for its calligraphy, but because Washington was Washington. Who cares how badly the signature is scribbled on a check, if the check doesn't bounce?

All this seems to imply that good design is superfluous. Design, good or bad, is a vehicle of memory. Good design adds value of some kind, gives meaning, and, not incidentally, can be sheer pleasure to behold; it respects the viewer's sensibilities and rewards the entrepreneur. It is easier to remember a well-designed image than one that is muddled. A well-designed logo, in the end, is a reflection of the business it symbolizes. It connotes a thoughtful and purposeful enterprise and mirrors the *quality* of its products or services. It is good public relations — a harbinger of goodwill. It says, "We care."

Logo, Monell Chemical Senses Center, 1989.
Size dramatizes, creates powerful contrasts and scale.

Logo, Mossberg & Company Inc., 1987. The design suggested a printing press to the client, although this was not intended. One reads into things what one is most interested in. Right: Logo, Benjamin Franklin 90th anniversary. The old and the new come together.

'90 B. Franklin

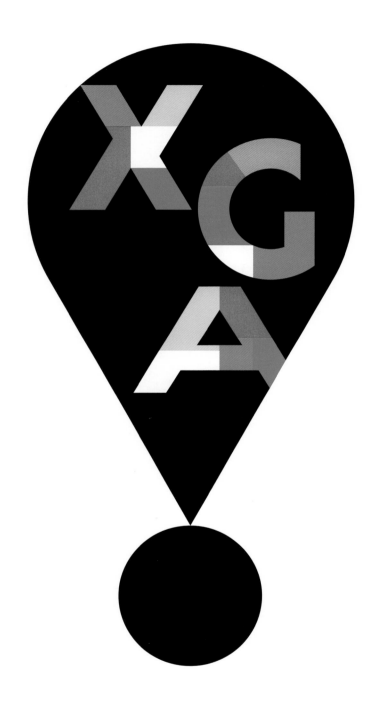

Logo, Irwin Financial Corporation, 1990. Numerals help explain the plus signs.
Repetition is a meaningful factor in design.
Left: Logo, IBM, 1992. An exclamation point serves as a foil for an exciting technology.

IBM identification, 1989. Art and technology—two jigsaw puzzles.

The Presentation

Canned presentations have the ring of emptiness. The meaningful presentation is custom designed — for a particular purpose, for a particular person. How to present a new idea is, perhaps, one of the designer's most difficult tasks. This *how* is not only a design problem, it also pleads for something novel. Everything a designer does involves presentation of some kind — not only how to explain (present) a particular design to an interested listener (client, reader, spectator), but how the design may explain itself in the marketplace. Not all assignments are equally interesting. The designer is expected to be inspired by the most mundane subject matter, no less by a dead fish than by a beautiful race horse. But subject matter in itself is not always inspirational. The relevant idea and its formal interpretation become the decisive factors.

A presentation is the musical accompaniment of design. A presentation that lacks an idea cannot hide behind glamorous photos, pizzazz, or ballyhoo. If it is full of gibberish, it may fall on deaf ears; if too laid back, it may land a prospect in the arms of Morpheus.

The following pages, with some exceptions, are replicas of brochures designed for the purpose of presentation. They follow a simple pattern, with generous use of white space and color to establish certain rhythms and to leave room for necessary pauses and logical transitions. White space is used as a functional not as an arbitrary device. It indicates timing and pacing and may be a determining factor in a given presentation. Its purpose is to help dramatize — a kind of backdrop separating one scene from another. To encourage reading, text is kept as brief and as readable as possible, with no attempt to confuse the reader with picturesque, typographic trickery. If type is shown in color, it is for reasons of emphasis, not theatrics. Caslon 540, Bodoni, and Univers are used exclusively.

1. Next 1986
2. The Limited 1988
3. IBM 1960
4. AdStar 1991
5. IDEO 1991
6. Morningstar 1991

What should a logo for Next look like?

Choosing a typeface as the basis for the design of a logo is a convenient starting point. Here are two examples: Caslon and Bifur. Caslon is an alphabet designed as far back as 1725 by William Caslon. It appears to be a good choice because it is both elegant and bookish, qualities well suited for educational purposes.

NEXT

Bifur, a novelty face by A. M. Cassandre, was designed in 1929. An unconventional but ingenious design, it has the advantage, to some, of visually implying advanced technology. *(Attributing certain magical qualities to particular typefaces is, however, largely a subjective matter.)*

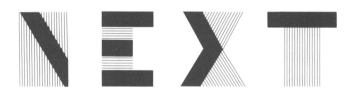

One reason for looking at a number of possible typefaces is to satisfy one's curiosity. Another, and perhaps more meaningful one, is to study the relationship of different letter combinations, to look for visual analogies, and to try to elicit ideas that the design of a letter or group of letters might inspire.

Here are some further choices, but no matter how one may look at these different examples — sans serifs, hairline and slab serifs, condensed, expanded, bold, light, outline — they still say *next* ... like *next time, what's next? next in line,* or even *next of kin.* The word is in such common usage that it is simply taken for granted.

Personal preferences, prejudices, and stereotypes often dictate what a logo looks like, but it is *needs* not wants, *ideas* not type styles that determine what its form should be. To defamiliarize it, to make it look different, to let it evoke more than the mere adjective or adverb it happens to be is, it seems, the nub of the problem.

NEXT

NEXT

NEXT

NEXT

NEXT

Next

Set in all capitals, the word NEXT is sometimes confused with EXIT, possibly because the EXT group is so dominant. A combination of capitals and lowercase letters helps to circumvent this problem.

Here are some possibilities that explore the use of lowercase letters.
The *e* is differentiated so as to provide a focal point and visual contrast amidst the straight and stalwart capital letters.

Happily, the *e* also could stand for: education
excellence
expertise
exceptional
excitement
$e = mc^2$
etc.

NEXT

next
Next
NeXt
NeXT
NeXT

Next

Note the difference that the lowercase *e* makes when compared with the capital *E*. By means of contrast, both interest and readability are achieved. This is particularly noticeable in the illustration at the bottom.

These simple, geometric letters make it easier to exploit and manipulate possible visual ideas than do more complex, serifed letters.

NEXT

NeXT

NeXT

Ideally, a logo should explain or suggest the business it symbolizes, but this is rarely possible or even necessary. There is nothing about the IBM symbol, for example, that suggests computers, except what the viewer reads into it. Stripes are now associated with computers because the initials of a great computer company happen to be striped. This is equally true of the ABC symbol, which does not suggest TV. The mnemonic factors in both logos are graphic devices.

In this example the *e* is the mnemonic element.

NEXT

NEXT

1. E. H. Grombrich,
"Image and Code,"
The Image and the Eye
(London, 1982), 287

A logo takes on meaning only if over a period of time it is linked to some product or service of a given organization. What is needed is a meaningful device, some idea that reinforces the memorability of the company name. A black cube, in which the product happens to be housed, can be such a device because it has a certain visual presence and is easy to remember. Unlike the word *next*, it is depictable and possesses the "promise of meaning, and the pleasure of recognition."[1]

This device in no way restricts its application to any one product or concept. The three-dimensional effect functions as an underscore and helps to attract the viewer's attention.

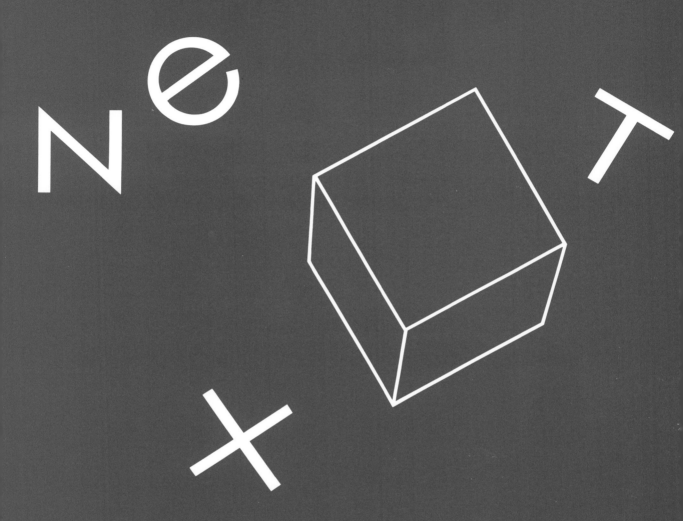

It is desirable to keep the letter style simple, unmannered, and untrendy
so as not to distract from the cube concept. Furthermore, the use of a single iden-
tification device and a simple sans serif letter, designed to harmonize
with almost any accompanying typeface, is essential for practical application.
Whenever possible, double identification (name plus symbol) is best
avoided. The brevity of the word NeXT and its containment within the framework
of the cube obviates the need for such awkward devices.

Splitting the logo into two lines accomplishes several things: it startles the
viewer and gives the word a new look, making it easier to separate from common
usage. Even more important, it increases the letter size, and hence the
readability, twofold within the framework of the cube.

For small reproductions, a one-line logo would have been much less legible within
this same framework.

Readability is hardly affected because the word is too simple to be misread.
Moreover, people have become accustomed to this stacking format with such
familiar four-letter word combinations as LO
 VE

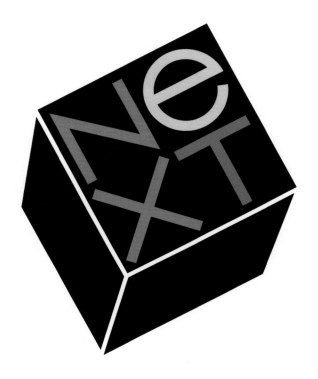

Next

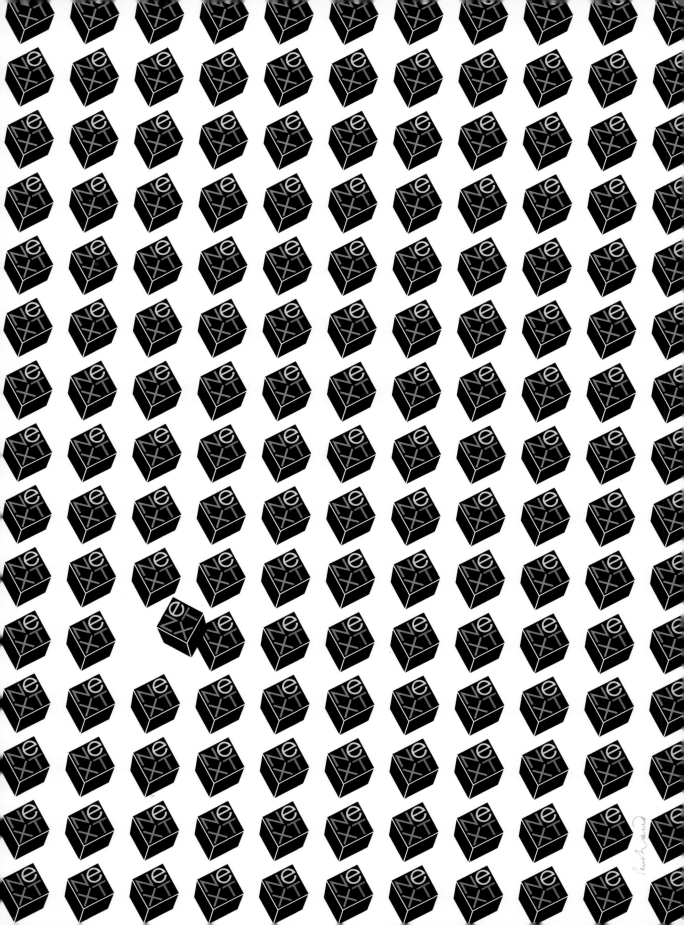

In its design, color arrangement, and orientation the logo is a study in contrasts. Tipped at a jaunty angle, it brims with the informality, friendliness, and spontaneity of a Christmas seal and the authority of a rubber stamp. Together with its lively black silhouette it becomes a focal point difficult for the eyes to avoid.

The unconventional yet dignified array of colors — vermilion against cerise and green, and yellow against black (the most intense color contrast possible) — is designed to appeal to a youthful audience and to add a sparkling, jewel-like touch to paper, package, or machine. It is the sparing use of brilliant colors on a predominantly black ground that produces this effect, like stars in the sky. In itself a decorative and self-contained device, the logo does not depend on extraneous embellishment or fancy backgrounds for its many varied applications.

Poised at an angle of twenty-eight degrees, the black cube — even without color — is equally effective for black and white reproduction.

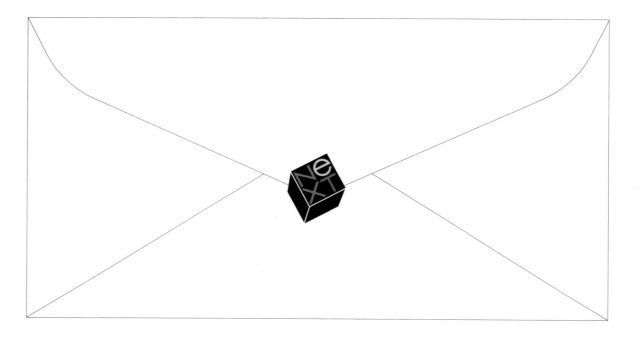

Next

The Limited

In 1925, Coco Chanel helped change the way one looks at fashion insignias. In the past, identification for products linked with fashion was rather delicate and wispy. Ideas were interpreted literally. The kind of vision it took to use a letterform traditionally associated with heavy industry, with trucks, for example, or, more appropriately, with posters or newspaper headlines, was revolutionary.

In 1992, however, the Chanel logo is as spry and timely as ever.

Today, almost anything goes. Visual identity for men's clothing is no different in spirit or in appearance from that of women's. Debates about serif versus sans serif have also fallen by the wayside. This clearly indicates that it isn't the style of letter — *the what* — that matters but the *idea* to which the letter is related: its application and use, its form, its color, its proportion and relationship to its surroundings — *the how.*

The fashion field is inundated with as many typefaces as there are fashion houses. Therefore, finding something new in letter designs is virtually impossible. The game of choosing a typeface for a particular purpose is often fortuitous, like the game of pinning the tail on the donkey. What a name or symbol should look like is based on many factors besides function: taste, prejudice, whim, business vicissitudes, demands — or imagined demands — of the marketplace, and mere arbitrariness are often the way a logotype is designed and chosen. And more often than not it is accompanied by market research, designed to imbue confidence and add a note of authority.

AnnTaylor.

CHANEL

ARMANI

The Limited

To design a logo that symbolizes a business such as THE LIMITED is an engrossing problem. It is also a baffling one. The name itself is ambiguous. What does *limited* mean — restricted, confined, within limits? Or does it mean exclusive? Is it a legal designation? Is it an adjective, a noun? Preceded by the definite article, one senses incompleteness: THE LIMITED *what?* If this were not complicated enough, according to Fowler's *Modern English Usage* the word is also often misused to mean "small, few, meager, or rare."

The Problem of Readability

Not only is the meaning of the word puzzling, but the very configuration, irrespective of letter style, is equally difficult to handle. Unlike the word CHANEL, for example, which begins with a circle, a square, and a triangle — three clearly differentiated shapes — LIMITED begins with a combination of three letters that present complex spacing and reading problems — in caps or lowercase. Furthermore, coming as it does at the end of the word, the *D* acts as a misplaced focal point and loses its effectiveness as a contrasting element.

THE LIMI TED

Regardless of context, many people associate capital letters with Roman inscriptions, proper nouns, and cautionary words such as STOP and DANGER. But this is not necessarily an argument against lowercase letters. More often than not lowercase may be more readable and certainly less formal than capitals, e.g., Ann Taylor, Benetton, Dior, etc. However, these are proper nouns and perceived as such, whereas LIMITED is an adjective. Nevertheless, people perceive capitals as more important, and more formal, thus more likely to be associated with company names.

Here are some steps toward a possible solution:

1. dots over the *i*'s help readability by calling attention to themselves, and by breaking the continuity of the repeating verticals
2. letter spacing helps readability as well, but what the word gains in readability it loses in compactness
3. with the exception of the *i*'s, the letters are pulled together, forming a compact, continuous ribbon. Word space as well as one of the vertical strokes has been eliminated and the total effect seems simpler.

THE LIMITED

THE LIMITED
THE LIMITED
THE LIMITED

The Limited

The problem of *The*

> A company name that begins with a definite article often presents a perplexing typographic problem. To circumvent this problem, the word is often set smaller and/or in lowercase or, sometimes, simply eliminated. But this rarely feels comfortable.
>
> Turning the word *the* on end, two things naturally follow: (1) the key word is emphasized, and (2) the two words at right angles to each other suggest the shape of the letter *L*, ''an optical memory image'' easily recognized from a distance before the words can ever be read. Placed at an angle, the square functions as a dramatic foil and adds a lively note to the logo.
>
> Eliminating the two *i*'s and dotting the verticals of the *M* makes the word more compact, more distinctive, and more memorable.

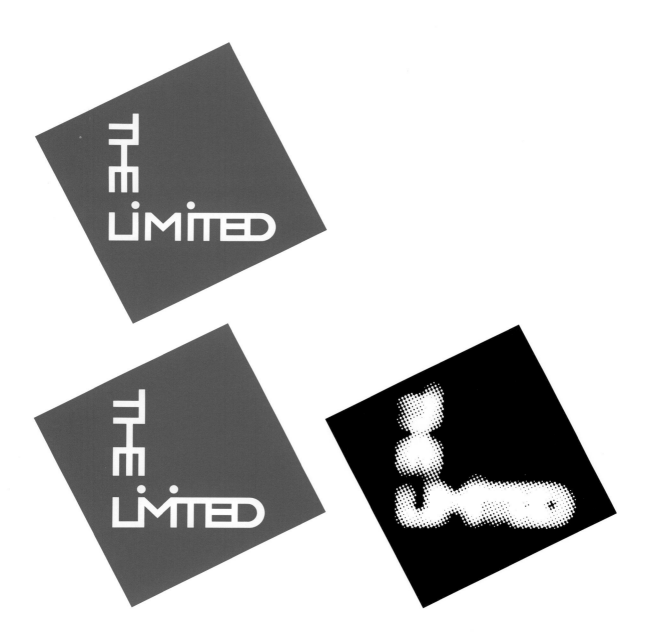

Doubling the stroke of each letter acts as a differentiating device, so that the verticals of the *M* now read as two distinct *i*'s. The word is now more readable and distinctly more decorative.

Some distinguishing features of the proposed design:

1. letters abut each other, forming a continuous horizontal ribbon
2. two capital *I*'s have been eliminated, shortening the word
3. by dotting the two verticals, the *M* serves as three letters — a kind of double entendre leaving the word itself clearly intact — a striking memory image
4. the triple letter combination evokes two people holding hands
5. the dotted *M* gives the name an unusual look
6. the dots may also be perceived as two eyes.

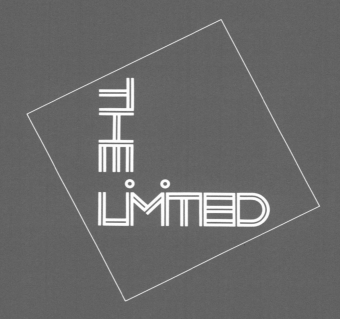

The Limited

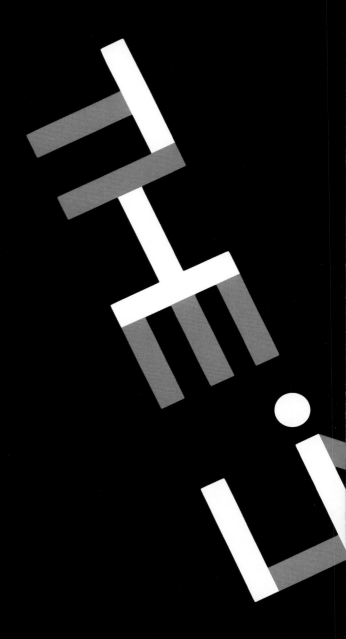

The Limited

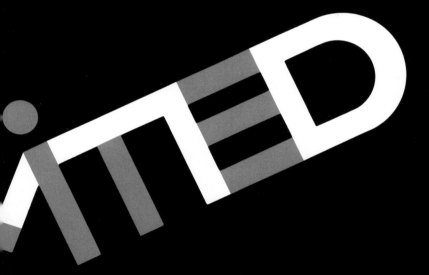

The Limited

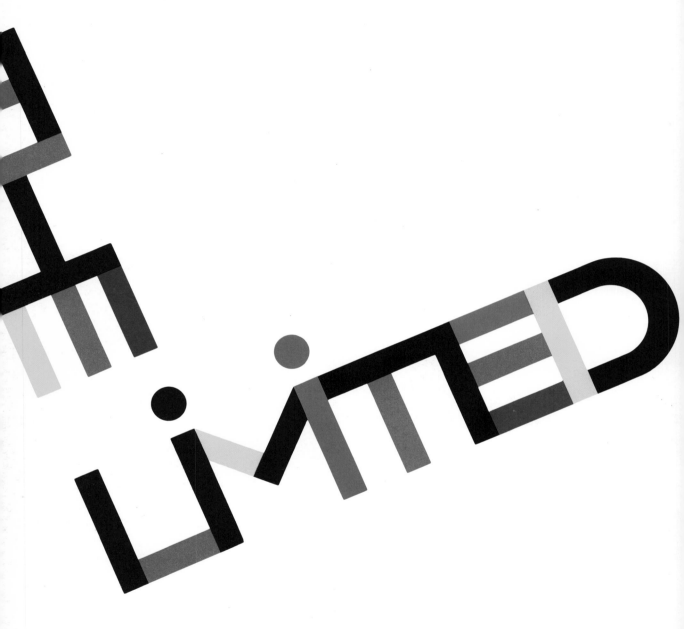

The Limited

The versatility of the logo is one of its more important qualities.
Here and on the following pages are three different designs for a shopping
bag bearing the new logo. It is easy to see that these same ideas can
be applied to packaging and to the numerous printed forms necessary to
carry out an effective design program.

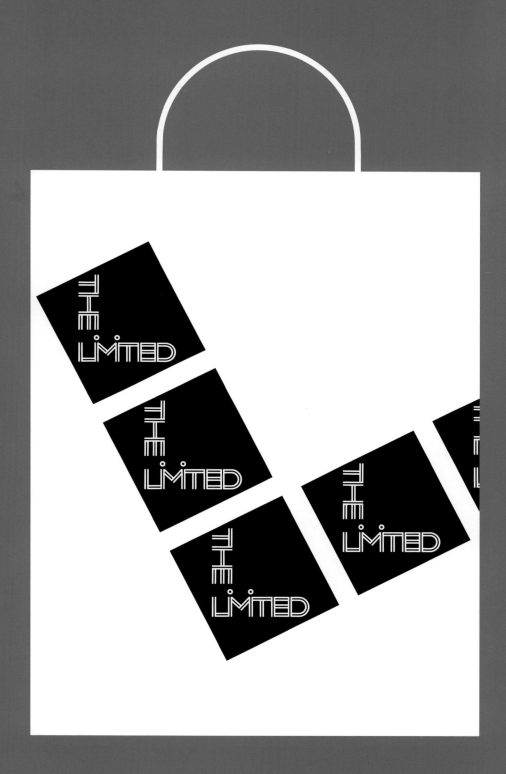

The Limited

Overall patterns are extremely useful for general design problems in which company identification is needed. Fabrics, carpeting, wallpaper, and wrapping paper are examples of commonly used items. This shopping bag features such a pattern.

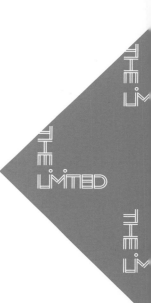

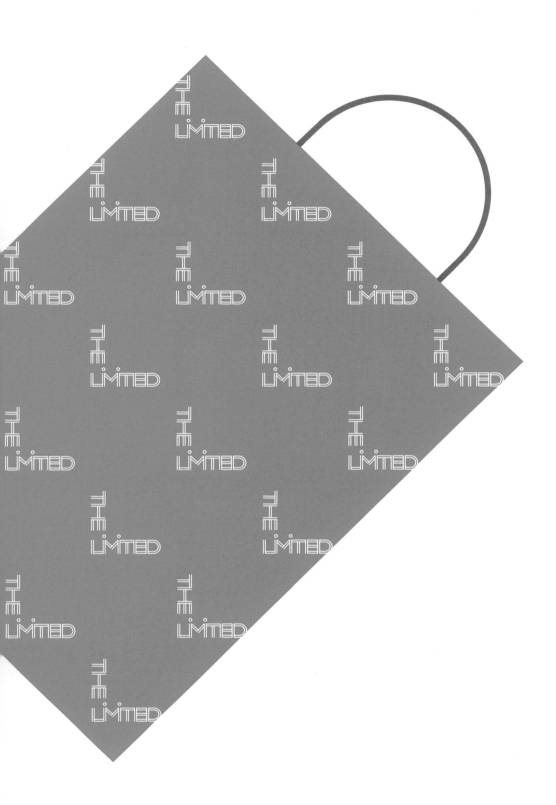

The Limited

The initial *L* may also be used as an overall pattern as well as an insignia.

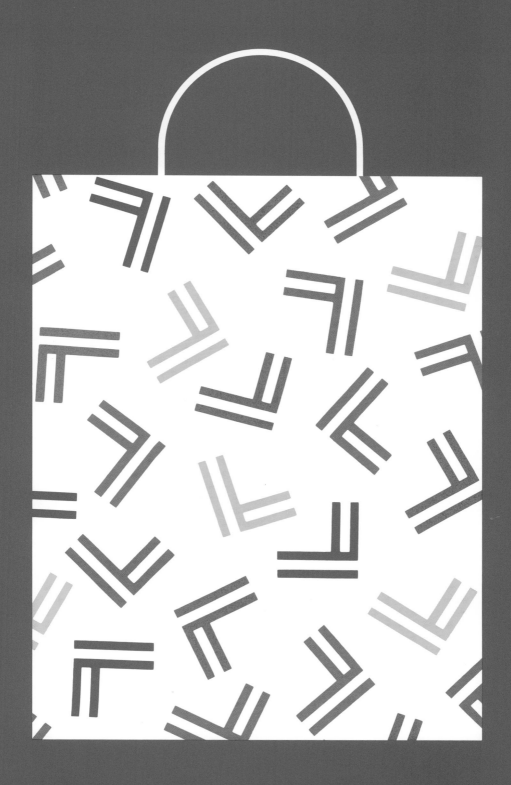

The Limited

The Limited Stores, Inc. Three Limited Parkway
Box 16528, Columbus, Ohio 43216
614 479 2000, Telex 245 362

The idea behind the design of a logo should, if possible, be elicited from the name it symbolizes. It should be distinctive — make some kind of statement. It should be in harmony with its purpose, easy to recognize, and easy to use. It should be something special, engage the viewer's attention, provide the joy of discovery and the pleasure of participation.

The design of a logo, which is the product of endless refinement and experiment, is ultimately a reflection of the integrity of the business it symbolizes. Its effectiveness is largely dependent on its exposure, how often and how well it is used.

The environment in which a logo is exhibited — its arrangement, color, lighting, and overall quality — is as important as the logo itself. Attention to detail, understanding, and receptivity are indispensable for the success of any logo. Its enduring qualities are embodied in the excellence and adaptability of its design and in its memorability.

The IBM Logo

The IBM logo is the IBM look...

The purpose of this brochure is to document the origin and development of the IBM logo, to illustrate its use, and to point to some of the design problems involved in its implementation.

The importance of the logo as a symbol of goodwill cannot be overestimated. For it is not simply a passive decoration on a nameplate or letterhead; it is also an active ingredient in the complex process of marketing and design.

The design of the IBM logo, like any design problem, is one of integrating form and substance — of making three familiar letters of the alphabet look different, attractive, memorable, and adaptable to an infinite number of applications.

Designed in 1956, it first appeared in two versions. The most
unusual aspects of the design are the square counters of the *B* and
the asymmetric serifs of the *M* — visual cues to aid recall.

Here is an early application of the outline version.
By trial and error, it became clear that the use of both a solid
and outline logo was self-defeating; it tended to confuse
rather than to reinforce company identity.

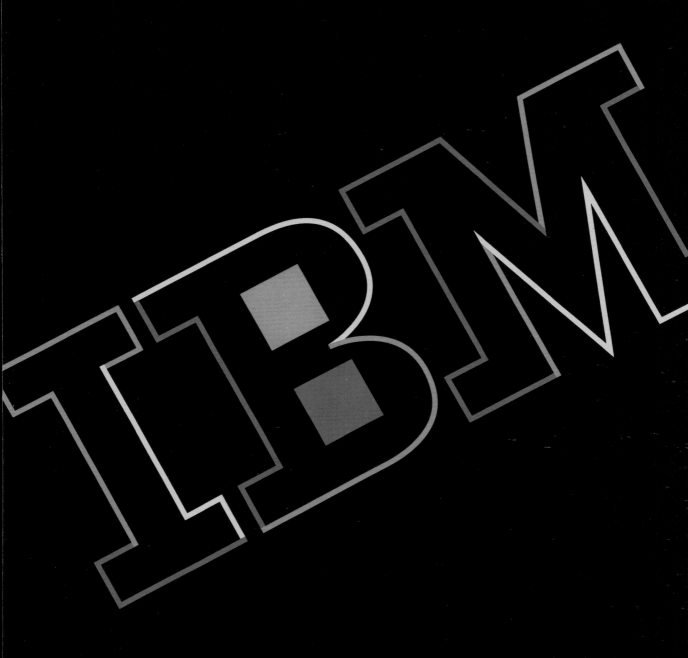

The IBM Logo

New Methods for Knowing

In its original form, the logo seemed too assertive. This condition
was alleviated by reducing the tonal value of each letter with a series
of stripes — a somewhat exaggerated benday — the idea of which
was suggested by the pattern of horizontal lines sometimes printed
on legal documents to discourage counterfeiting.

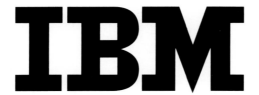

The 13-line logo was designed to accommodate those requirements calling for a more restrained visual interpretation, for example, legal documents and certificates. Technical problems such as printing, embossing, die cutting, and engraving largely determine whether the 8-line or 13-line logo should be used.

For most applications, however, the 8-line is preferable.
If a more discreet visual effect is needed, it may be grayed down to approximate the tonal value of the 13-line logo.

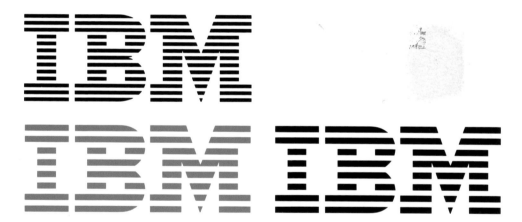

A sampling of color variations suggests some design possibilities. Color can trigger different moods and signal different functions, depending on context: color coding, seasonal themes, patriotic celebrations, symbolic associations, or just plain fun.

At no time is the integrity of the logo altered. Variety and surprise are achieved simply by color alternation.

The IBM Logo

In this illustration, color coding is used to differentiate one software product from another. To preserve a family resemblance, only one of the alternating colors changes — red/blue, green/blue, yellow/blue, etc.

This 1974 annual report cover represents an unusual departure for IBM: up through 1990, it was the only cover that featured typographic art rather than color photography. The logo, tilted at an angle of 37 degrees, became the standard format for many design applications.

The exaggerated size of the logo has less to do with identity than with its decorative qualities. Function and ornament are one.

The 37-degree angle was an arbitrary design decision but once fixed helped to assure uniformity for many different applications.

Geschäftsbericht '74

Here is the first of a series of packages that feature the IBM logo at a 37-degree angle. It serves as a means of identity as well as a decorative, attention-compelling device.

The IBM Logo

Stripes have appealed to people of dramatically different per-
suasions and cultures. Stripes evoke exciting images of Romanesque
architecture, African ornament, and Parisian fashions. They are
part of a geometry that decorates and animates. Stripes are indelibly
linked with the IBM image and serve a useful function as a
background pattern.

Multicolored stripes make an easy-to-remember ensemble of packages. Rearrangements of such patterns in horizontal, vertical, or diagonal format are as abundant as the variables of geometry.

Even the slightest suggestion of stripes says IBM.

The IBM Logo

The logo, as an illustrative device, serves the dual
purpose of identifying a business and dramatizing a visual idea.
Three possibilities are shown on the following pages.

1. An explosion of logos serves as a visual metaphor for confetti
 in this 75th anniversary poster.

2. Here's how the logo can help identify an IBM product at the same time that it is incorporated into a product name.

The IBM Logo

3. A logo within a logo. Here again the logo serves a dual purpose in identifying a new affiliate: Palisades Education Center.

As a decorative element, the multicolored logos evoke
the richness of medieval book illumination and lend authority
to an official document.

1957
Joseph F. Talerico
1988

IBM IBM IBM IBM IBM IBM IBM IBM IBM

In Appreciation
for your Contribution to the
IBM
Design Program

Innovation has, for years, put IBM in the forefront of the business community. For the writer, the designer, the engineer, the marketer — for anyone involved in the creative process — it is difficult to exaggerate the importance of this fact.

Innovation leads one to see the new in the old and distinguishes the ingenious from the ingenuous. It frowns on clichés and déjà vus, as it recognizes the difference between freakishness and freshness. It is the lifeblood of intuition, imagination, and invention — the essence of originality.

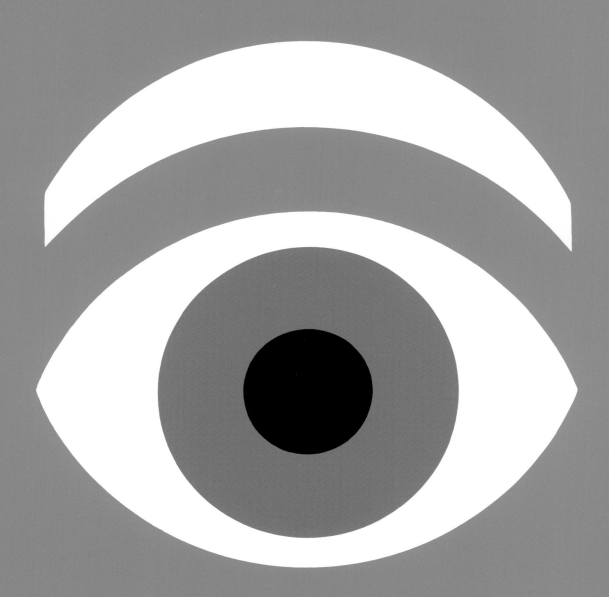

The IBM Logo

The history of design at IBM is the history of innovation and
hard work. Innovation distinguishes the leader from the follower, never
satisfied with what has been, but intent on what will be. It is the
driving force of the creative spirit, sensitive to change and the change-
less. It focuses not only on what is right, but on what is exceptional.
Surprise, not predictability, is its hallmark.

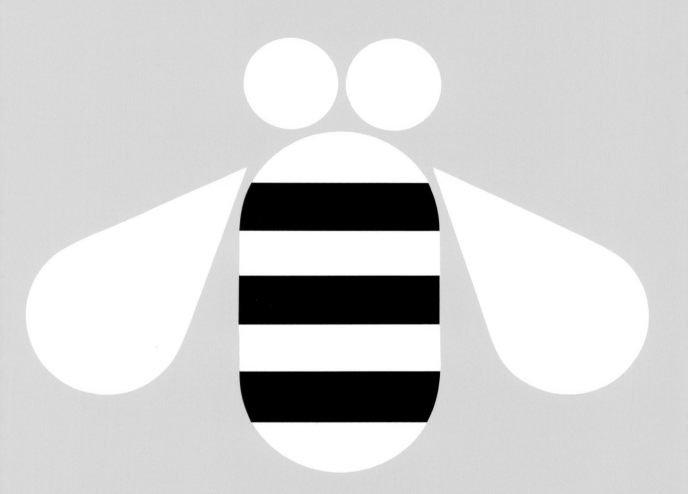

The IBM Logo

Innovation does not always, or even necessarily, imply dramatic change. Design is innovative even if it is merely interpreted in an unexpected way. Innovative solutions are more the product of restraints than of freedoms — of cultural limitations, scarcity of funds and materials, production capabilities, and demands of the marketplace.

Innovation is the enemy of trendiness, pretense, and timidity. It recognizes the genuine from the spurious. It tantalizes the viewer, stimulates the mind, intensifies meaning, generates interest, and is at the heart of both better design and better business.

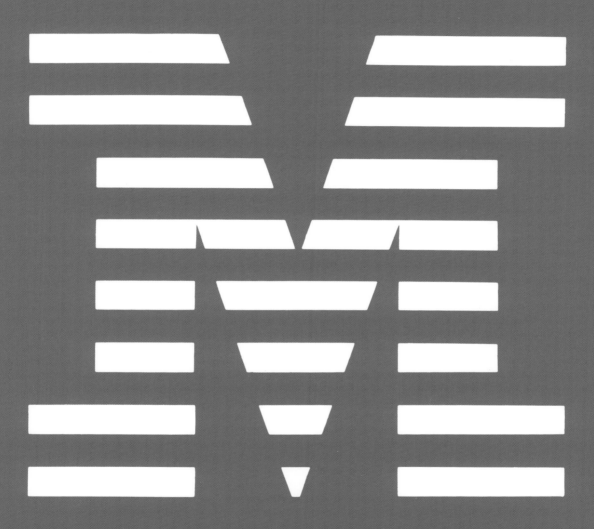

The IBM Logo

AdStar Advanced Storage and Retrieval

1. Letter combinations and letter sequences are determining factors in
 the design of most logos.

 The example shown is a straightforward interpretation of the
 word *Adstar*. It does little to lead the spectator away from its most obvi-
 ous interpretation: *Ad* = advertising, *star* = Hollywood. The *Ad*
 configuration is phonetically and visually separated from the com-
 plete word.

2. In the next version the *dS* combination introduces a jumbled effect.
 The two-color combination somewhat alleviates the complication.

Adstar

AdStar

3. This rendition is an improvement over the first two examples but the typographic problems still exist.

4. The acronym ASR is now clearly separated from the auxiliary letters. In addition, the acronym visually punctuates the word, making the whole easier to visualize and remember. More important, bringing the acronym to life within the compound words tends to enrich both the visual and verbal meaning. Because the mix of caps and small caps lends dramatic contrast, the use of more than one color is unnecessary.

AdStaR

AdStaR

ADSTAR

An IBM Company

Route 100 P.O. Box 100
Somers
New York 10589

Ray S. AbuZayyad
General Manager

ADSTAR

An IBM Company

Route 100 P.O. Box 100
Somers, New York 10589
914 766 1900

AdStar

IDEO Design

Pictures, abstract symbols, materials, and colors are among the ingredients with which a designer or engineer works. To design is to discover relationships and to make arrangements and rearrangements among these ingredients.

All design involves combinatorial geometry.

The logo for IDEO is based on this discipline. This geometric emphasis, incidentally, is appropriate in terms of form *and* content. Just as proportion and contrast are aspects of form, *appropriateness,* that is, fitness to purpose, is an aspect of content no less than are function and materials. Barring some unusual situations, appropriateness is germane to good design. A beautiful rendition that is inappropirate is, by definition, not good design.

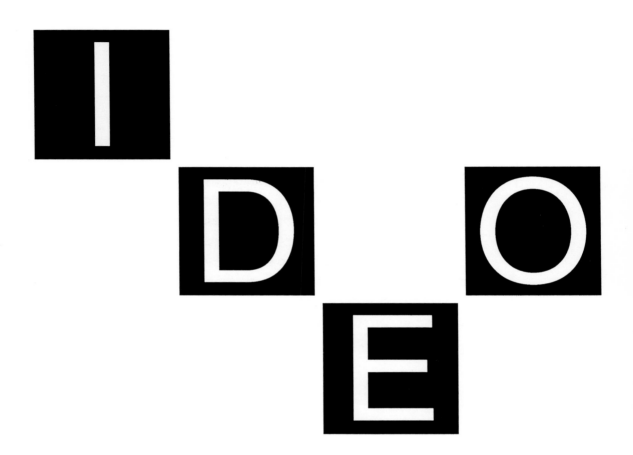

Here are some variations on the theme of four squares. The frieze motif, vaguely reminiscent of Egyptian hieroglyphs, is not only engaging but is indicative of the way a designer might go about testing an idea. It also impels the spectator to participate in the design process — to try her or his hand at different configurations.

Repetition of the letters *I-D-E-O* is integral to the design idea of the logo, demonstrating some of the variations that are possible with a given device. It is both a reflection of a mode of thinking and an illustration of a specific design solution. Repetition, then, becomes an aid to remembering. Accent on only one of the components provides a focal point. It also provides a contrasting element that is aesthetically necessary in a linear design. Pronunciation is aided by separating each letter. The *I,* being sequentially predominant, provides a clue to its emphasis.

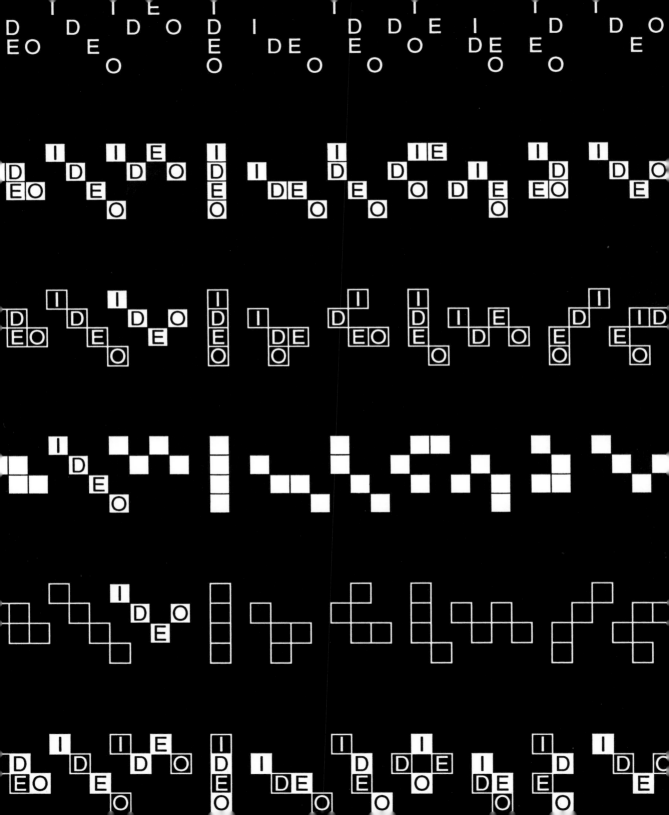

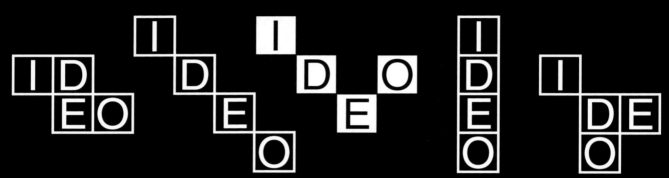

164.

IDEO

Morningstar Investment Advisers

1. A short word is easy and pleasant to read.

MORNINGSTAR is the compounding of two words. It is neither short nor easy to read.

This (opposite) is easier to read...
but there are problems inherent in this combination of letters that are impossible to avoid.

As a single word, Morningstar seems unwieldy.
The letter combinations *NIN*, *GS*, and *TA* tend to form clusters and separate from the whole, causing difficult spacing problems.

Condensing each letter saves space and insures compactness.
The signature is now perceptively shorter and easier to manage.

MORNINGSTAR

2. In most printed ephemera, the size of signatures tends to be small.
 The problem of readability becomes even more significant.

 Readability, however, is not our only concern.
 Without the element of recognition, without some unique and memo-
 rable visual device, readability plays a minor role.

 The *Coca-Cola* signature, for example, can be "read" even when
 the letters are too small to see; the *word-profile* is familiar and
 visually recognizable as a shape rather than as a configuration of
 individual letters and swashes.

MORNINGSTAR

3. The word Morningstar begins to take on some mnemonic
 value when a star configuration replaces the letter *O*.

M✳RNINGSTAR

4. A single round *O* that serves as a dynamic contrast to the accompanying condensed letters seems less trite. However, it lacks the element of surprise — something, perhaps, which will cause the *O* to suggest the idea of a sun, a kind of pictorial punctuation that adds interest while it colors meaning.

MORNINGSTAR

5. This solution is reminiscent of the tantalizing puzzle
How to make an egg stand on end. Trimming the base of the circle
suggests a rising sun.

The name Morningstar was inspired by the last line of Thoreau's
Walden: "The sun is but a morning star." Its visual interpretation is
also based on this quotation.

MOR

Morningstar

INGSTAR

Computers, Pencils, and Brushes

Except for the absence of human sensibility, the computer is a most awe-inspiring machine. But the language of the computer is the language of technology, not the language of design. It is also the language of production. It enters the world of creativity only as an adjunct, as a tool — a time-saving device, a means of investigating, retrieving, and executing tedious jobs — but not as the principal player. In education this art versus production dilemma is inescapable. The moment the balance is disturbed in favor of production, the computer becomes a hindrance to invention and a barrier to the link between mind and work.

"Because the modern world lives by machinery," comments a distinguished educator, "it favors the mechanical in all things, whether all things benefit from it or not."[1] To the extent that the machine replaces the hand and prevents the student from practicing the manual skills, the computer is an intruder. To the extent that computer theory replaces, and is confused with, design theory, it is equally misplaced. The ambience of the art school is not the ambience of the computer environment. If computer skills are demanded in the the job market, students must, somehow, find time to learn these skills. Once students feel at home with design — and this takes a very long time — they are free to choose their tools. A Yale student once said, "I came here to learn *how to design,* not how to use a computer." Design schools take heed.

In an even more serious vein, the author of *Technopoly* comments: "What we need to consider about the computer has nothing to do with its efficiency as teaching tool. We need to know in what ways it is altering our conception of learning, and how, in conjunction with television, it undermines the old idea of school.... New technologies alter the structure of our interests: the things we think about."[2]

"It's only a tool, like a pencil or brush." This often-quoted remark is as seemingly innocent as it is disingenuous. Clearly the computer is more than a pencil or brush. For storing information, for producing intricate configurations and accurate diagrams, for eliminating the ennui of repetitive operations, and for doing things swiftly it has no equal. However, concepts and ideas spring from the mind and not from the machine. Without a knowledge of design, the computer (like the pencil) is more than useless, for it is capable of producing enough

1. Jacques Barzun, "Middlemarch," *Begin Here* (Chicago, 1991), 28

2. Neil Postman, "The Judgment of Thamus," *Technopoly* (New York, 1992), 19, 20

superfluous material to create the illusion that one is inventing when, in fact, one is merely producing variations on a theme, often of nothingness. This problem is particularly irksome in the field of design education. The student who has been concentrating on learning the intricacies of the computer feels a sense of accomplishment once he or she has mastered the machine. This creates the impression that one is now a competent designer when, in fact, one has been conditioned to "see" (like Pavlov's dog) mechanics rather than aesthetics, speed rather than direction. All this means, of course, is that the student has not been deeply involved in the study of design. However, he or she now has the necessary qualifications to enter a design studio, with the prospects of winding up a second- or third-rate typesetter.

Because it confuses technique with form, discussions about whether the products of the computer are a legitimate art form are irrelevant. They act as a red herring to divert one from the real subject at hand, which is not technology but design. It is a truism that every technique yields its own unique mannerisms, but this has less to do with ingenuity than it does with the accidents of technology. The notion of the computer as a "creative tool" is misleading in that it implies that invention is a matter of pushing buttons and moving around a cursor. The kind of images that the computer can generate may also be misleading, in that they often *look* new; again, this conundrum is more a matter of technique than of substance. The phrase "the tool of the future" is equally suspect. It seems also to suggest that the hand and mind will eventually become atrophied. All in all, what these expressions have in common is that they promise more than they can deliver.

This is not to deny the real fascination computers hold for all of us; the prospect of sitting down to "play" with a machine is a heady one. But at the same time this play may sidetrack students from the real work of design, the step-by-step participation in the process of thinking through a problem. It may also deprive students of the drawing skills that develop only after hours and hours of practice, pencil or pen to paper.

This drawing and the one on page 185 were executed by students with ruling pen, straight edge, and compass. Peter Motel, Kunstgewerbeschule, Basel.

One wonders if what happened to handwriting with the invention of the type-writer will happen to other manual skills with the intervention of the computer.

It would, obviously, have been faster and much easier to render these two drawings by computer. But this would have meant the loss of valuable practice and experience in the use of tools and materials. "Working out [the] steps by hand," says Jacques Barzun, "gives the mind that 'feel of the material' which is essential to mastery in any art or trade."[3] As for the sensibilities that flow "only through the sinews of unmediated experience,"[4] these too would have been lost to the workings of a moving cursor. Equally lamentable, the students would have been deprived of the pleasure of accomplishment.

For every competent designer, there is a host of competent computer operators whose numbers account for the kind of trendiness that is saturating printed media today. Of course, the computer, like any special tool, will produce visual effects not possible by other means. Inarguably, the virtue of the computer for the designer is the abundance of graphic possibilities it lays before him or her. In the hands of a thoughtful designer, this may be useful. Computers may even help in the creative process by suggesting visual possibilities unimaginable with other techniques, or by helping to solve problems *specifically designed* for the computer's capabilities. But this same virtue or potential is easily exploited for the sake of effect by designers who may or may not have learned the difference between an effect and its essence. The baffling complexity of much computer-generated design today is a testament to this learning gap.

When to use computers is certainly as important as how to use them. In the school environment, they should be a part of the curriculum but not *the* curriculum: nothing can replace the hand in the early stages of design education.

3. Jacques Barzun,
"The Urge to Be Pre-Posterous,"
Begin Here
(Chicago, 1991), 92

4. Bill McKibben,
The Age of Missing Information
(New York, 1992)

Kyoko Tateno, Yale University.

Yale University
School of Art Graduate Program:
1989–1990

One of the purposes of a professional education in the visual arts is to expose the student to a series of experiences similar to those he or she will confront in the daily life of an artist. At Yale, it is our intention to provide an educational context within which promising students with strong motivation and dedication can pursue their disciplines in depth. The essential experience of a student's two years here is likely to be found in the practical work of the studio, whether in the solitary exploration of the painter, sculptor, or photographer, or in the problem solving activity of the designer. Such work will be supported and enriched by knowledge and skill gained from formal studio courses within the School, and in academic courses chosen from the resources of the entire University. Each student is exposed to a wide range of aesthetic and critical positions, both through contact with the regular faculty and with the many visiting artists who are invited to the School each term. Our aim is to provide a visual education and to build—by rigorous study, challenge and discussion—aesthetic positions founded not on the fashions of the moment, but on each student's sense of history and firm personal conviction. What cannot be taught, but only recognized and supported, is creative energy and imagination. Such attributes are the student's own. —*David Pease, Dean*

M.F.A. Programs of Study:

The Yale University School of Art offers professional studies leading to the Master of Fine Arts degree. Men and women holding a Bachelor's degree from an accredited college or university or a diploma from a four-year accredited professional art school are eligible to apply to one of the following areas of study: graphic design, painting/printmaking, photography or sculpture. Normally the course of study is completed in two years.

The School of Art also offers a course of study for students in Yale College including a major in art in the areas of graphic design, painting/printmaking, photography, and sculpture. The instruction in these programs is provided by the faculty of the School of Art.

Who Can Qualify:

The University is committed to basing judgements concerning the admission, education, and employment of individuals upon their qualifications and abilities and affirmatively seeks to attract to its faculty, staff and student body qualified persons of diverse backgrounds. In accordance with this policy and as delineated by federal and Connecticut law, Yale does not discriminate in admissions, educational programs, or employment against any individual on account of that individual's sex, race, color, religion, age, handicap, or national or ethnic origin; nor does Yale discriminate on the basis of sexual orientation. University policy is committed to affirmative action under law in employment of women, minority group members, handicapped individuals, special disabled veterans, and veterans of the Vietnam era. Inquiries concerning these policies may be referred to Charles H. Long, Deputy Provost of the University, 118 Hall of Graduate Studies or Frances A. Holloway, Director of Affirmative Action, 80 Wall Street, 203-432-0849.

Applications:

For Preliminary Selection, applicants are evaluated by Admissions committees on the basis of a slide portfolio combined with academic records, recommendations, and statement of intent. All candidates for admission must apply to a specific area of study (graphic design, painting/printmaking, photography, sculpture). The application fee is $60 and applications for admission must be complete in all respects no later than February 1, preceding the September for which admission is sought. Applicants who have passed the Preliminary Selection will be notified by mail prior to March 1. At this time, for Final Selection purposes, applicants will be asked to send or deliver actual work and will be invited to schedule an appointment for an individual interview. Final notification of admission will be mailed in mid-April. Acceptance is not dependent upon the student's financial position.

Tuition:

The tuition for 1990–91 is under review and will be announced in the spring. The current tuition rate is $10,790.

Financial Aid:

The School of Art, in conformity with University policy, offers financial assistance to applicants only after the applicant has been accepted for admission and only if a GAPSFAS analysis is on file with the School. Assistance is based upon need and limited by available resources within the School. Although the number of students receiving financial aid varies each year, in 1988–89 approximately 80 percent of students in the School were receiving some form of financial aid. Tuition Scholarships, long term loans and employment opportunities are integral to the School's financial aid program. The School of Art offers a special program of assistance based on minority status through the Ford Foundation. While Foreign Nationals are not eligible for Federal loans or work-study programs, some University scholarships may be available.

Additional Resources:

Resources available to students who attend the School of Art include:

The Yale University Art Gallery
The Art Library which includes a slide collection and photographic archives
The Department of History of Art
The Yale Center of British Art and British Studies
The Audio Visual Center
The Art and Architecture Gallery in which student work is exhibited
The Beinecke Rare Book Library

Inquiries:

All requests for the current School Bulletin (which contains more detailed information) and application forms should be addressed to the Office of Academic Affairs, Yale School of Art, 1605A Yale Station, New Haven, Connecticut 06520.

An Open House introduction to the School at which representative members of the faculty will discuss the programs and visitors will be given a guided tour of the facilities will take place on Wednesdays, 29 November, 1989. All prospective applicants are encouraged to attend.

School of Art Faculty 1989–1990

Graphic Design:

The graphic design program admits 18 students each year. They share two large design studios with related workshops and facilities for photography, letterpress typography, computer-aided typography, drawing, printmaking and bookbinding. Each student has a faculty advisor, but the entire faculty is available to all the students for criticism. Class work involves theoretical studies, work on applied problems and individual projects. Group meetings are held each term to give all the students and faculty members an opportunity to review the complete work of the term.

Faculty
Greer Allen
Charles Altschul
Matthew Carter
Inge Druckrey
Alvin Eisenman, *Director of Studies*
Colin Forbes
John Gambell
Jane Greenfield
John Hill
Armin Hofmann
Dorothea Hofmann
Jan Murray
Christopher Pullman
Paul Rand
Douglass Scott
Bradbury Thompson
Edward Tufte
Min Wang

Painting and Printmaking:

Approximately 22 students are accepted by this department each year. Studies are based on tutorial contact and on formal class work. Students are exposed to a broad range of discussion with faculty and visiting artists. Group critiques are an important feature of the program. Each student is allotted a private studio. Printmaking equipment available includes two lithography and three etching presses. Students may concentrate in either Painting or Printmaking or both.

Faculty
William Bailey
Frances Barth
Mel Bochner
Charles Capon
Wiley Carr
Bernard Chaet
Natalie Charkow
Andrew Forge, *Director of Studies*
John Hull
Susana Jacobson
Richard Lytle
Catherine Murphy
David Pease, *Dean*
Andrew Raftery
Robert Reed
Richard Ryan
John Walker

Photography:

Graduate photography is a two-year program of independent study admitting a maximum of 7 students per year. Besides regular criticism from resident faculty, additional criticism is offered by visiting artists. Special technical instruction is available to interested students. Studio and darkroom facilities are provided.

Faculty
Richard Benson
Susan Kismaric
Tod Papageorge, *Director of Studies*
Steven Smith
Nancianne Vizzini
Jo Ann Walters

Sculpture:

The two-year sculpture program is currently accepting 8 students a year. There is good studio space, adequate wood and metal working equipment. There are no casting facilities. There are periodic critiques by the faculty and the students are exposed to many distinguished visiting artists.

Faculty
Alice Aycock
Erwin Hauer
Lucio Pozzi
Kathleen Schimert
David von Schlegell, *Director of Studies*

Visiting Artists / Lecturers:

The following are the visiting artists and scholars who participated in the programs of the various departments during 1988–89, offering individual critiques, workshop seminars, and formal lectures.

Vito Acconci	Rex Hennessey	Gabor Peterdi
Dennis Adams	Catherine Howett	Lisa Pomeroy
Laura Albin	Faith Hubley	Pike Powers
Avigdor Arikha	Tishan Hsu	Lucio Pozzi
Luis Cruz Azaceta	David Ireland	Aimee Rankin
David Berlow	Ronald Jones	Ed Rath
Sigrid Bovensiepen	Reed Kay	David Reed
Ann Breazeal	Susan Kismaric	Michael Roemer
Lowery Burgess	Jeff Koons	Jeremy Gilbert-Rolfe
Gary Burnley	Josef Koudelka	Michael Ross
Tony Butler	Gabriel Laderman	Sal Scarpitta
Luis Cancel	Eddie Lee	Steve Sheehan
Jackie Casey	Donald Lipsky	Elizabeth Sledge
St. Clair Cemin	Ellen Lupton	Art Spiegelman
Margot Clark	Danny Lyon	Robert Stackhouse
Kate Ericksen	Sally Mann	Joel Sternfeld
Lauren Ewing	Carlo McCormick	Fred Thursz
Jan Ferris	George McNeil	Marcia Tucker
Larry Fink	Judy Metro	Meg Webster
Karen Finley	William Mitchell	Wolfgang Weingart
Eric Fischl	Catherine Murphy	Henry Wessell Jr.
Herb Fox	Eric Neudel	Stanley Whitney
David Gibson	John Newman	Wolfgang Wodicko
Helen Harrison	Graham Nickson	Sylvia Woodard
Newton Harrison	Thomas Palmer	Mel Ziegler

Design: Paul Rand Composition/design: MCT Inc. Typesetting: PDR, New York City

Computers, Pencils, and Brushes

I wonder if the fuss about computers in design schools may not simply be a decoy to show that the school is au courant; or does it indicate some other problem? The tangibles of computer technology are obviously easier to cope with than the intangibles of design.

The illustration at left was designed to poke fun at the computer, yet it would have been virtually impossible to accomplish without one. In contrast, the illustrations on this and the following page could have been accomplished equally well by hand or by computer, except that the latter would have been faster.

Yale University
School of Art Graduate Program:
1990–1991

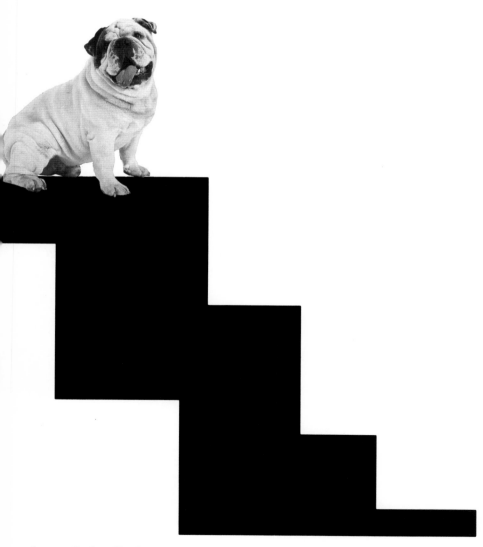

Computers, Pencils, and Brushes

Aspects of Book Design

This chapter was originally a review of Eric Gill, *An Essay on Typography* in *The New York Times Book Review* (September 10, 1989)

Eric Gill's admirable little book, first published in 1931 in a limited edition, is important less for its erudition about the theory and practice of typography than for the moral support it gives to artists, whose principal concern is the quality of their work; to businessmen, who are chiefly interested in the bottom line; and to printers and publishers, who are more concerned with traditional practices than with wild ideas.

Even though *An Essay on Typography* deals with technical difficulties, the history and evolution of letters, the craft of typography, type design and manufacturing, page makeup, color and ink preparation, paper making, book binding, publishing, and even orthography, it is written with clarity, humility, and a touch of humor. Eric Gill's writing style moves between a chuckle and a grimace, avoiding a lot of technical jargon and pretentious allusions. And the British Gill, who was not only a typographer but a sculptor, engraver, and writer, panders to no one. One wonders how so much could have been packed into such a tiny package — probably enough to have made experts in typography and printing like the Americans Daniel Berkeley Updike and Theodore L. De Vinne marvel.

Gill's ultimate goal, like that of any serious artist, had less to do with means than with ends — the proper balance between form and content, between man and machine. He cautions the worker not to get too involved with the machine. "It is important that the workman should not have to watch his instrument, that his whole attention should be given to work." "The mind," he further asserts, "is the arbiter of letter forms, not the tool or the material." For those dazzled by the computer, who see the machine as a magic muse, these words are particularly useful.

On more than one occasion he implies that the businessman's involvement in aesthetics is incidental, not intentional. "And the printer whose concern is quality," he says, "is not a man of business." Similar expressions — "by men of brains rather than by men of business" and "the history of printing has been the history of commercial exploitation" — sum up Gill's attitude about industry, even though he owed much of his livelihood to English type founders.

He even advises the publisher where the company's name should appear in a book and calls the ordinary title page "a showing off ground...an advertisement for the printer and publisher." The names of printer and publisher, he says, should appear at the end of the book where they logically belong. The design of the title page of the 1931 edition, for example, is a masterpiece of understatement, containing the title, the author's name, and the table of contents in a design so splendid that, even today, it would be considered revolutionary.

Speaking of some typographers' grammatical conventions, he comments, "the absurd rule that the ampersand should only be used in 'business titles' should be rescinded, & there are many other contractions which a sane typography should encourage." He also frowned on such traditional practices as fitting a particular typeface to a particular subject, citing people who believed that "reprints of Malory should be printed in 'Black Letter' and books of technology in 'Sansserif.' " He agreed that for certain subjects the practice could be useful but argued that it is wrong as a general rule. He had much to say about mixing typefaces as well, preferring not to do so even if the face originally chosen was inferior.

He compared the compositor's stick to a "Procrustean Bed," because the typesetter uses it as "the easiest way out of the difficulty caused by the tyrannical insistence on equal lengths of lines," thus pointing out the logic of ragged right setting. He also emphasizes the importance of reasonably close and even spacing of words and letters, for the sake of legibility and looks. And, in the last chapter, he even thrashes out the problems of the unreasonableness of English spelling, displaying some very useful examples to make his point.

This 1936 jacket for Gill's essay, although not a model of the "new" typography,
is far more contemporary than the 1989 edition.

AN ESSAY ON TYPOGRAPHY by Eric Gill, comprising a Composition of Time & Place (p. 3) and chapters as follows: on Lettering (p. 25), on Typography (p. 61), on Punch cutting (p. 77), on Paper & Ink (p. 83), on the Compositor's 'Stick', here called "the Procrustean Bed" (p. 90), on the Instrument (p. 97) and a final chapter on the Book (p. 105).

4 ¶ The full force of this abnormality is not apparent to the majority; perhaps no more than ten people in England see it. This state of affairs, though now deliberately fostered and definitely stated in many places, has been very gradually arrived at—it is only recently that it has arrived at any sort of completeness; but it is now almost complete and has come to be regarded as in no way contrary to nature and actually to be a normal state of affairs.

¶ This is not the place to demonstrate the steps by which the world has come to such views & to such a condition, nor to discuss the ethical causes and consequences. It is sufficient for our purpose to describe the world of England in 1931, & it is necessary to do that in order that we may see what kind of world it is in which the thing called Typography now exists.

¶ We are concerned with Typography in England; it may be that the conditions are much the same in France, Germany and America, but we have no means of being certain of this. Moreover there are differences of language and even of lettering which make it necessary to restrict the circle in order to avoid confusion. ¶ What sort of a place, then, is England? It should now be possible to describe

Eric Gill, Typography, *1936. Left, title page, right, typical design for text pages.*

To Gill's eye, lettering was "as beautiful a thing to see as any sculpture or painted picture." Yet the relationship between words and spelling, between printed words and speech, he considered irrational, and he suggested that some sort of shorthand system, which he called phonography, be provided as a possible solution. "We need a system in which there is real correspondence between speech…the sounds of language and the means of communication." This had nothing to do with speed. "Think slowly, speak slowly, write slowly" is what he exhorted his readers.

Although Gill was not a functionalist in the Bauhaus tradition, readability, not fashion, determined the form of his designs. And his design of this book (at least the earlier editions) is consistent with the contents, a fine example of form following function.

Eric Gill was described by one of his compatriots as having "a common-sensical twinkle in his alert eyes." His dress was that of a maverick but his demeanor was proper and unaffected. He was an enigma, his life a paradox, as Fiona MacCarthy's startling recent biography revealed, but his work was essentially traditional. His words, for the most part — and one can quibble about some of his ideas — are as pertinent today as they were almost 60 years ago, when his book was written. To say more about Gill's thoughts and ideas is to contradict his notions of simplicity and brevity. His work and words speak eloquently of his art. But there is something more to say about the design and typography of the 1989 edition, which, after all, should not contradict the author's ideas. It is puzzling that the publishers chose to photocopy the 1954 rather than the 1936 edition of this book. The Joanna typeface, the ragged setting, the paragraphing, the use of the ampersand and contractions, to be sure, are all there. But the type seems too large and obtrusive, the page proportionately too small for the large type, the paper too bulky and insufficiently opaque, and the book too thick and clumsy for its size. This version misses the subtlety of earlier editions. In a certain sense, it's like altering the author's text to suit the publisher's preferences or prejudices.

What is more perplexing is the design of the new jacket, which, besides seeming
a bit prissy and glaringly inappropriate to the spirit and contents of the book,
would probably have seemed dated even in 1931. The 1936 and 1954 jackets featured
a very large title in Gill Sans type, which was more authoritative and more suit-
able for the purpose of attracting the prospective buyer. It served also as a dramatic
visual complement to the small format, while it proudly announced that this is
a book about letters and not about fairy tales.

Having said all this, I still find the contents of this book timeless and absorbing
for the layman and practitioner, student and teacher, for those who love to read, and
for those who love the shapes of letters.

A Mentor

für den neuen menschen existiert
nur das gleichgewicht zwischen
natur und geist zu jedem zeit-
punkt der vergangenheit waren
alle variationen des alten ›neu‹·
aber es war nicht ›das‹ neue· wir

1. A paper published in 1925, demonstrating the views and achievements of the New Typography.

Cézanne had been dead nineteen years and Cubism was celebrating its eighteenth birthday when Jan Tschichold wrote "Elementare Typographie."[1] The art "isms" new and not so new had been around for some time: Impressionism, Pointillism, Cubism, Futurism, Suprematism, Constructivism, Neoplasticism, and Dadaism. But names such as Mondrian, Schwitters, Arp, Malevich, Van Doesburg, Kandinsky, Marinetti, Le Corbusier, and Lissitzky, who represented the avant-garde of painting, architecture, and typography, were often greeted with indifference or outright hostility by a culture that thrived on traditional ways of seeing and believing. This hostility was reflected, for example, in the Dutch government's denial of representation to members of *de Stijl* at the International Exhibition of Decorative Arts held in Paris in 1925. Similarly, Le Corbusier's *Pavilion L'Esprit Nouveau* at this same exhibition was "erected in the face of implacable hostility."[2] It was in such an atmosphere that Tschichold began his work on what was to be known as the New Typography.

2. Le Corbusier, *Creation Is a Patient Search* (New York, 1960), 49

Even though typography per se is based largely on practical needs, the New Typography, as Tschichold saw it, was deeply rooted in aesthetic problems. It was based on ideas that were generated by, among others, the Constructivists, who stressed the "utilitarian aspects of artistic order." And it was also influenced by the utopian ideas of members of *de Stijl,* who "wanted to create a style appropriate for every aspect of contemporary life, one so coherent, so intelligible, and so complete that the distinctions between art and life would eventually be erased, when everything produced by human agencies, from tea cups to town plans, would participate in a universal, visual and intellectual harmony."[3]

3. George H. Hamilton, *Painting and Sculpture in Europe 1880-1940* (New Haven, 1967), 206

It is evident that there were at this time two distinct forces simultaneously at work on Tschichold. On the one hand, there were the practical lessons learned from such traditional designers as Edward Johnson of England and Rudolf von Larisch of Germany. And on the other, there was the experimental work of a small group of industrious innovators (painters, architects, decorators) who must have deeply affected his thinking. Among this latter group were Kurt Schwitters, with his collages and his children's books (done in collaboration with Kate Steinitz and Theo Van Doesburg); El Lissitzky, with his constructions, exhibition work,

Left: Tschichold's Single-Alphabet type design, 1929.

and typographic experiments; Moholy-Nagy, with his typographic innovations for the Bauhaus publications; and Piet Zwart, with his distinguished typography for Dutch industry. Tschichold not only responded to the work of these innovators but recognized what most did not: the needs of the time. "The existence of the new typography," he stated, "can be said to be due to the personal achievements of its initiators; but to me it seems more accurate to regard these as the exponents of the tendencies and practical needs of our time."[4]

Tschichold recognized more than the needs of his time; he also saw the interrelationship of the present, past, and future. His chief contribution was a synthesis, a distillation, of the ideas of those who represented the two extremes. He was the catalyst who helped transform a traditional craft into a contemporary art form.

In 1928 he published *Die Neue Typographie,* a book which has since become the classic statement on modern typography.[5] By word and picture, by formulation and teaching, he helped to illuminate not only the New Typography but the new vision of which typography was but one manifestation.

The world was his classroom and typography his voice. But the voice that so confidently and earnestly advanced the cause of the New Typography began, with equal sincerity, some few years later (after *Typographische Gestaltung* was published)[6] to preach the virtues of traditional ideas. *Die Neue Typographie* was dismissed with an old Chinese proverb: "In haste there is error."

Discussions for or against Tschichold's conversion have been misleading because they are to a large extent ad hominem arguments. Even though the printed page may ultimately have cultural or historical significance, typography, that is, the appearance of the printed page, is essentially a formal question. Whether that form is symmetrical or asymmetrical, serif or sans serif, is less a question of contemporaneity than a question of spatial interpretation.

4. *Commercial Art* (London, July 1930)

5. Jan Tschichold, *Die Neue Typographie* (Berlin, 1928) Some of the resistance and misunderstanding elicited by the ideas expressed in *Die Neue Typographie* of 1928 are still with us in 1993. I hasten to say, however, that the sans serif of 1928 is not the Cooper Black of today. The former was a product of serious reflection, the object of which was not a question of novelty but of function. But the latter is a product of fashion, and its success has less to do with its intrinsic merits than with its association with a prevailing fad, a kind of "plop art."

6. Jan Tschichold, *Typographische Gestaltung* (Basel, 1935) *Typographische Gestaltung* was translated for the first time in English in 1967 under the title *Asymmetric Typography* (New York and Toronto). The reader should compare the typography and formats of both editions.

JAN TSCHICHOLD

DIE NEUE TYPOGRAPHIE

EIN HANDBUCH FÜR ZEITGEMÄSS SCHAFFENDE

BERLIN **1928**

VERLAG DES BILDUNGSVERBANDES DER DEUTSCHEN BUCHDRUCKER

Though not an example of a really beautiful page, Die Neue Typographie *showed the "way," and was the harbinger of many beautiful pages.*

Schönste liebe mich

Deutsche Liebesgedichte
aus dem Barock und dem Rokoko

Mit farbigen Wiedergaben
acht alter Spitzenbildchen

Verlag Lambert Schneider,
Heidelberg

To judge Tschichold's work in terms of fashion or popularity would be equally misleading, since these values are not intrinsic to the work itself. Whether one talks about the New Typography and the old Tschichold or the old typography and the new Tschichold, one finds a common denominator which seems to embrace these apparently contradictory concepts, and which distinguishes all of Tschichold's work. That is a sense of quality.

The meaning of quality as such is indefinable, but it is somehow intuited in the presence of the work in which it is embodied. This has little to do with popular conceptions of beauty, taste, or style and has nothing to do with status, respectability, or extravagance. It is revealed, rather, in an aura of propriety and restraint. Quality deals with the judicious weighing of relationships, with balance, contrast, harmony, juxtaposition between formal and functional factors — their transformation and enrichment.

Further, quality is concerned with ideas not techniques, with the enduring not the ephemeral, with precision not fussiness, with simplicity not vacuity, with subtlety not blatancy, with sensitivity not sentimentality.

In the Orient, calligraphy has always been accorded a place of honor in the hierarchy of art forms. In the West, typography, the mechanical extension of calligraphy, has traditionally been looked upon as a practical minor art. It is due largely to the efforts, the stubbornness if you like, of men like Tschichold that Gutenberg's mechanical convenience has become a vehicle for genuine modern expression. Typography, no matter how it is viewed, remains a difficult, subtle, and exacting art. And even though a certain degree of technical skill is relatively common, typographic mastery is the province of the perceptive and the prerogative of the few.

Left: Title page, Tschichold 1957. Quality takes precedence over style.

From Cassandre to Chaos

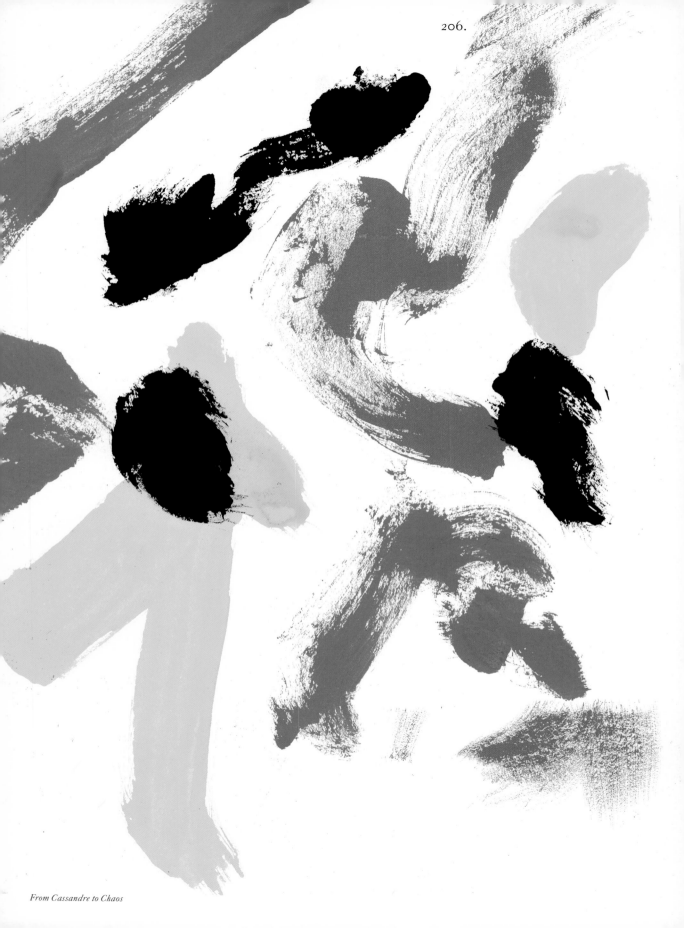

"I feel that the ideas that I tried to outline…will strike many of you as consisting too much of the atrabiliar grumblings of a disgruntled elder," is how Roger Fry, the distinguished British art critic, expressed the fear that a message he was trying to deliver might be falling on deaf ears.
(Roger Fry, Art and Commerce, *London, 1925, 23*)

In the history of painting and design, from Cimabue (1240–1302) to Cassandre (1901–1968), communication between artist and spectator was rarely a problem. Today, the emphasis on style over content in much of what is alleged to be graphic design and communication is, at best, puzzling. *Order out of chaos* is not the order of the day.* The deluge of design that colors our lives, our print, and our video screens is in harmony with the spirit of our time. No less than drugs and pollution, the big brush of graffiti, for example, has been blanketing our cities from Basel to Brooklyn. Much of graphic design is a grim reminder of this presence.

The qualities that evoke this bevy of depressing images are a collage of chaos and confusion, swaying between high tech and low art, and wrapped in a cloak of arrogance: squiggles, pixels, doodles, dingbats, ziggurats, and aimlessly sprinkled liliputian squares; turquoise, peach, pea green, and lavender; corny woodcuts on moody browns and russets; art deco rip-offs, high-gloss finishes, sleazy textures; halos and airbrush effects; tiny color photos surrounded by acres of white space; indecipherable, zany typography; tiny type with miles of leading; text in all caps (despite indisputable proof that lowercase letters are more readable, less formal, and friendlier); ubiquitous letterspacing; visually annotated typography; revivalist caps and small caps; pseudo Dada and Futurist collages; and whatever "special effects" a computer makes possible. These *inspired decorations* are, apparently, convenient stand-ins for real ideas and genuine skills.

Even though some of these ideas and images may be useful from time to time, when they are employed relentlessly and indiscriminately they become mere clichés. This is what defines trendiness.

* H.L. Mencken's caustic, but hilarious critique of Warren G. Harding's inaugural address roughly echoes my feelings about the state of much of design today: "It reminds me of a string of wet sponges; it reminds me of tattered washing on the line; it reminds me of stale bean soup, of college yells, of dogs barking idiotically through endless nights. It is so bad that a sort of grandeur creeps into it. It drags itself out of the dark abysm of pish and crawls insanely up the topmost pinnacle of posh. It is rumble and bumble. It is flap and doodle. It is balder and dash." ("The Impossible H.L. Mencken," *New York Times Book Review,* 1992)

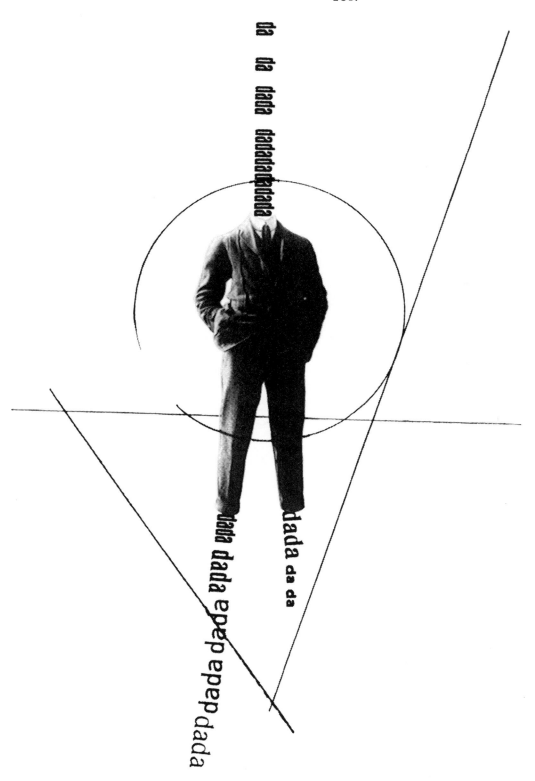

The Memphis fad, for example, was based on clichés and on outrageous, kitschy notions. (Occasionally, however, some potentially useful ideas seeped through — only proving that it takes talent to make something out of nothing.) The huge expenditures involved in the manufacture and storage of Memphis products have probably helped speed its demise. Printed ephemera, however, which involve less capital, are bound to circulate longer.

Graffiti and graffiti-like design have a certain affinity with WWI Dada. Both are revolts, one against the lopsided conventions of the early twentieth century, the other (it seems) against anything that is deemed "old hat" in the 1990s. But whereas today's Dada, if it can be called that, thrives on its trendiness, the work of WWI Dadaists was not in any way trendy; it was serious, witty, and always interesting. The protagonists of early Dada are known to us now, of course, as great artists and reformers: Hans Arp, George Grosz, John Heartfield, Marcel Duchamp, Max Ernst, Kurt Schwitters. Who from today's Dada, I wonder, will be remembered in fifty years?

Most of this "new" style of design is confined to pro bono work, small boutiques, fledgling studios, trendy publishers, misguided educational institutions, anxious graphic arts associations, and a few innocent paper manufacturers, who produce beautiful papers but then spoil them with "the latest" graphics, and who, undoubtedly, see themselves as the avant-garde — and are comforted by the illusion that this must be progress. Unhappily, this is infecting some of the graphics of the corporate world: annual reports, identity programs, direct mail, etc. Trendiness is seductive, especially to the young and inexperienced, for the principal reason that it offers no restraints, is lots of "fun," permits unlimited possibilities for "self-expression," and doesn't require conforming to the dictates of aesthetics. "Self-expression is real only after the means to it have been acquired,"[1] comments the author of *Begin Here*, a brilliant commentary on the foibles of education.

1. Jacques Barzun, "The Centrality of Reading," *Begin Here* (Chicago, 1991), 25

This surprisingly playful montage by George Grosz (circa 1920) anticipates techniques of a much later date. It has none of the earmarks of present day obscurant design. It exhibits the same wit and irony as his illustrated social commentaries.

From Cassandre to Chaos

"Some esthetic products," writes John Dewey, "have an immediate vogue; they are the 'best sellers' of their day. They are 'easy' and thus make a quick appeal; their popularity calls out imitators, and they set the fashion in plays or novels or songs [or designs] for a time. But their very ready assimilation into experience exhausts them quickly; no new stimulus is derived from them. They have their day — and only a day."[2]

2. John Dewey,
"The Organization of Energies,"
Art as Experience
(New York, 1934), 167

Lack of humility and originality and an obsession with style are what seem to encourage these excesses. Absence of restraint, equating simplicity with shallowness, complexity with depth of understanding, and obscurity with innovation distinguish the quality of work of these times. The focus on freedom and canon-bashing further suggests a longing to reject the past — *the infinite greatness of the past* is how Walt Whitman put it. All this, of course, carries little weight with critics who, out of hand, reject the styles of their predecessors and respond to reason with disdain.

Added to all this is the obsession with theory that, instead of being fuel for action, as it was at other times (during the Renaissance, for example), is merely the vehicle for fathomless jargon,* variously described as "extravagantly obscure, modish, opaque verbal shenanigans — and the authors as masters of impenetrability."[3] Although these descriptions are aimed at architects, they seem equally appropriate for graphic design theorists of the "new" (a buzzword often seen in advertising, sometimes preceded by the expression "amazing"). Reaching for the *new* is tilting at windmills; the goal ought not to be what is *new* (original), as Mies put it, but what is *good*.

3. Roger Kimball,
"Deconstruction
Comes to Architecture,"
Tenured Radicals
(New York, 1990), 123

Twenty-eight years ago, my friend Charles Eames (1908 – 1977) spoke at the Pasadena Art Museum concerning a growing preoccupation with the problem of creativity. "This preoccupation in itself," said Eames, "suggests that we are in some special kind of trouble — and indeed we are."

* Jargon is the language of pseudoknowledge; hardened metaphor substitutes for reality, and premature certitude substitutes for the kind of curiosity and reflection that waits patiently for a phenomenon to emerge in its full disorderly and often elusive complexity. — *The New York Times.*

NEW

A look at graphic design today suggests that perhaps we are in even greater trouble now than we were then. As a matter of fact, design today is reminiscent of the trials of an earlier era, in which Edward Gibbon, author of *The History of the Decline and Fall of the Roman Empire* (1776), astutely described the arts in theater, music, and painting as "freakishness pretending to originality, enthusiasm masquerading as vitality."[4] Eames would probably turn in his grave if he knew what was happening even in academia today. "It is no secret," asserts the author of *Tenured Radicals*, "that the academic study of the humanities in this country is in a state of crisis....Every special interest — women's studies, black studies, gay studies, and the like — and every modish interpretive gambit — deconstructivism, post structuralism, new historicism [post modernism],...has found a welcome roost in the academy [and in many studios], while the traditional curriculum and modes of intellectual inquiry are excoriated as sexist, racist, or just plain reactionary."[5] "It is also necessary," adds another critic, "to remind oneself of the dangers that ensue when metaphors substitute for facts, when words lose their meaning, and when signifiers and signifieds part company, with the deconstructionists' blessing."[6]

Today, the popular sport is to put down whatever is not perceived as change — in other words, all but the very latest — subjects such as the curriculum, modernism, functionalism. For example, the Bauhaus, into whose history is woven the very fabric of modernism, is seen as a *style* rather than as an idea. To say that the Bauhaus and its ideology are irrelevant is to dismiss as well its antecedents: Ruskin and Morris, the arts and crafts movement, the Secessionists, Hoffmann and Moser, Muthesius and the Werkbund (1907), Behrens, van de Velde, the director of the Weimar Academy, Gropius, Klee, Kandinsky, Moholy-Nagy, Albers, Mies, and outsiders such as Malevich, Mondrian, Van Doesburg and Lissitzky. Cubism and some of its progeny — suprematism, neoplasticism, constructivism, futurism — were its aesthetic and ascetic foundation. The Bauhaus Archives in Berlin, the refurbished building in Dessau, and original products now available to all are startling evidence that the Bauhaus is breathing vigorously.

4. Alistair Cooke, *America Observed* (New York, 1988), 14

5. Roger Kimball, *Tenured Radicals* (New York, 1990), xi, xiii

6. David Lehman, "A Scandal in Academe," *Signs of the Times* (New York, 1991), 243

7. A. N. Whitehead,
"Requisites for Social Progress,"
Science and the Modern World
(New York, 1925), 289

"There are two principles inherent in the very nature of things," writes Whitehead, "the spirit of change, and the spirit of conservation. There can be nothing real without both. *Mere change without conservation is a passage from nothing to nothing.* Mere conservation without change cannot conserve."[7]

Interminable disputes about whether design at the Kunstgewerbeschule of Basel is focused too much on form at the expense of other goals is to deny what Mies espoused: "Form is not the goal but the result of our work."

Fads are governed by the same immutable laws of form as are other visual phenomena. Wishful thinking will not make them go away; and one can no more escape from the exigencies of form than from one's shadow.* To poke fun at form or formalism is to poke fun at Roger Fry, Clive Bell, John Dewey, and the philosophy called aesthetics. Ironically, it also belittles trendy design, since the devices that characterize this style of "decoration" are primarily formal. Furthermore, it denies what the great historian, painter, and architect of the Renaissance, Giorgio Vasari, had already stated about design (form): "*It is the animating principle of all creative processes.*"[8]

8. T. S. R. Boase,
"The Critic,"
Giorgio Vasari
(Washington, D.C., 1971), 124
(emphasis mine)

The quality of teaching in the university and art school is rarely taken to task. To teach in a university practical experience, it seems, is not one of the prerequisites (at least, not long-term experience). Experience in the workplace, and a thorough knowledge of the history of one's specialization is indispensable, both for imparting information and for one's well being. But such experience, with some exceptions, is rare among students as well as among faculty. Absence of these disciplines can only help perpetuate mediocrity, and insure the continual flow of questionable work in the marketplace.

But for the familiarity with a few obvious names and facts about the history of painting and design, history is a subject not taken too seriously. This does not imply that just because some work is a product of the past it is privileged, willy-nilly, to join the ranks of the immortals. The historical process is (or should be) a process of distillation and not accumulation. In a certain sense it is related to natural selection — survival of the fittest. Furthermore, to shun history is to reinvent the wheel — the probability of repeating what already has been done.

* The Matisse show (September 1992) is "a profound rebuttal to those who doubt the power of art on purely visual (formal) terms." *The New York Times,* September 20, 1992.

Gutenberg, Picasso, cubism, futurism, Lissitzky and Tschichold are among
the historical facts and figures that a student or teacher may be aware of. But
what about the history of art going back to pre-Renaissance, which is so well
documented? What about the history of design, largely a product of journals and
a few isolated books that are not always well documented?

Even though students may be familiar with artists of the 1890s such as Lautrec,
Bonnard, and the Beggarstaff brothers, they are not likely to recognize even
the names of designers of the 1920s and 1930s. If the artist happens to wear two
hats — a painter as well as a designer — more time is spent on the relative
merits of "fine" as opposed to "applied" arts than on intrinsic values. Mention
of some of the Europeans (not necessarily linked with the avant garde)
whose work appeared in periodicals such as *Gebrauchsgraphik* and *Arts et Métiers
Graphiques* before WWII will, probably, be greeted with silence.

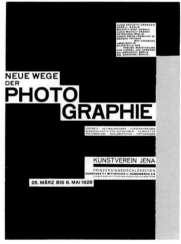

O. H. W. Hadank Walter Dexel Max Koerner

By no means is this a complete roster: F. H. Ehmcke, Tommi Parzinger, Julius Klinger, Otto Arpke, Karl Schulpig, Lucian Bernhard, Walter Dexel, Max Buchartz, Hans Leistikow, Valenti Zietara, Wilhelm Deffke, Anton Mahlau, Georg Goedecker, Fritz Ahlers, O. H. W. Hadank, Albert Fuss, Max Koerner, Julius Gipkens, Otto Boehm, Dora Mönkemeier Corty, Paolo Garetto, Pierre Brissaud, Paul Renner, Fortunato Depero, Hans Schleger, Rudolf Koch, Georg Trump, Charles Martin, Paul Scheurich, Bernard Bouté de Monvel, Ludwig Kozma, Paul Colin, Josef Binder — designers, illustrators, fashion artists, and others too numerous to list. And among Americans, in the 1930s and 1940s, there were Gustav Jensen, Howard Trafton, (Bobri) Vladimir Bobritzki, Joseph Sinel, George Switzer, and Edward McKnight Kauffer, who spent most of his life in England. Great designers such as William Addison Dwiggins or Eric Gill occupy a different genre.

Fortunato Depero

Fritz Ahlers

Anton Mahlau

These designers, and many others, were my silent mentors. Magazines were a great school for learning. Today there are a scattered few great designers; but they do not come in bunches as they did in the 1920s and 1930s, but what we have instead is an abundance of great salesmen.

Both in education and in business graphic design is often a case of the blind leading the blind. To make the classroom a perpetual forum for political and social issues, for instance, is wrong; and to see *aesthetics as sociology* is grossly misleading. A student whose mind is cluttered with matters that have nothing directly to do with design, whose goal is to learn *doing* and *making,* who is learning how to use a computer at the same time that he or she is learning design basics, and who is overwhelmed with social problems and political issues is a bewildered student. This is not what he or she bargained for nor, indeed, paid for.

"Schools are not intended to moralize a wicked world but to impart knowledge and develop intelligence, with only two social ends in mind: prepare to take on one's share in the world's work and, perhaps in addition, lend a hand in improving society *after* schooling is done."[9] Anything else is the nonsense we have been living with. Further on Barzun continues, "All that such good samaritan courses amount to is pieties. They present moralizing mixed with anecdotes, examples of good and bad, discussions of that catchall word 'values,'" and finally, he admonishes, "Make the school a place for academic vocational instruction, not social reform."[10]

In decrying this situation I do not suggest that social or political issues are mere trivia. On the contrary, they are of real significance and deserve the kind of forum that is free of interference. Even though common decency implies continuing concern for human needs — and good design means attention to *all* needs, social or otherwise — social issues are not aesthetic issues, nor can they be the basis for aesthetic judgments. Where, for example, would Caravaggio, Lautrec, or even Degas be if work were judged on issues *other* than aesthetics? And where, today, would so many schools, studios, and advertising agencies be if important decisions depended on aesthetic priorities?

9. Jacques Barzun, "Ideas versus Notions," *Begin Here* (Chicago, 1991), 50

10. *Ibid.,* 208

Campaign contribution, 1993. A Big Apple for the Big Apple.